CREATING CREATURES *of* FANTASY AND IMAGINATION

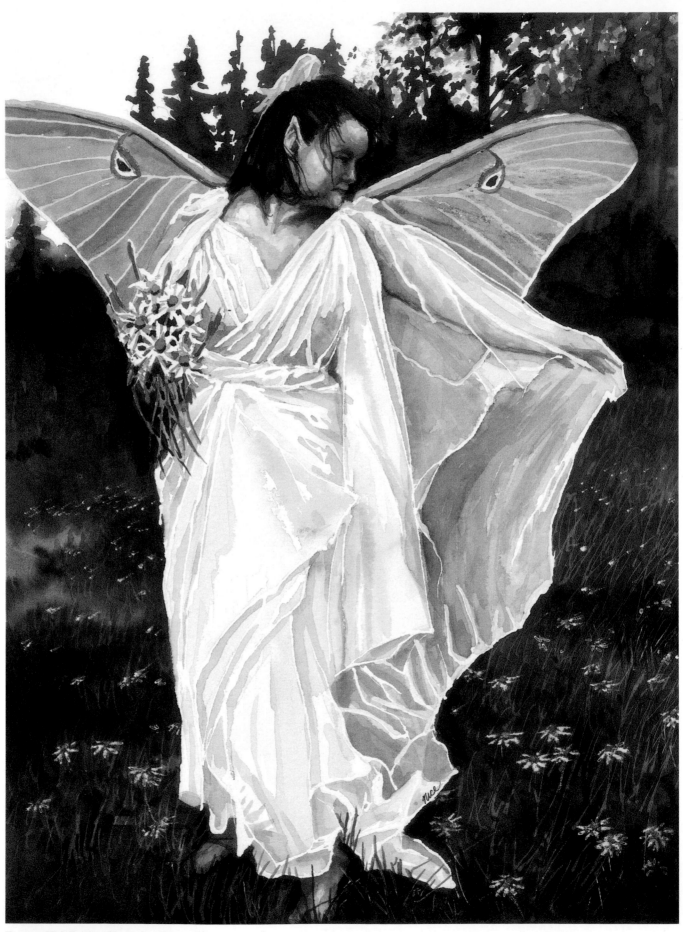

Dancing With Daisies / Watercolor / 8" × 10" (20cm × 25cm)

Creating Creatures of Fantasy and Imagination

EVERYDAY INSPIRATIONS
for **Painting Faeries, Elves, Dragons,**
and more!

Claudia Nice

NORTH LIGHT BOOKS
CINCINNATI, OHIO
www.artistsnetwork.com

About the Author

Creating Creatures of Fantasy and Imagination. Copyright © 2005 by Claudia Nice. Manufactured in China. All rights reserved. No part of this book may be reproduced in any form or by any electronic or mechanical means including information storage and retrieval systems without permission in writing from the publisher, except by a reviewer who may quote brief passages in a review. Published by North Light Books, an imprint of F+W Publications, Inc., 4700 East Galbraith Road, Cincinnati, Ohio, 45236. (800) 289-0963. First Edition.

fw
F+W PUBLICATIONS, INC.

Other fine North Light Books are available from your local bookstore, art supply store or direct from the publisher.

09 08 07 06 05 5 4 3 2 1

DISTRIBUTED IN CANADA BY FRASER DIRECT
100 Armstrong Avenue
Georgetown, ON, Canada L7G 5S4
Tel: (905) 877-4411

DISTRIBUTED IN THE U.K. AND EUROPE BY DAVID & CHARLES
Brunel House, Newton Abbot, Devon, TQ12 4PU, England
Tel: (+44) 1626 323200, Fax: (+44) 1626 323319
Email: mail@davidandcharles.co.uk

DISTRIBUTED IN AUSTRALIA BY CAPRICORN LINK
P.O. Box 704, S. Windsor NSW, 2756 Australia
Tel: (02) 4577-3555

Library of Congress Cataloging in Publication Data
Nice, Claudia.
 Creating creatures of fantasy and imagination / Claudia Nice.
 p. cm.
 ISBN 1-58180-618-3 (alk. paper)
 1. Fantastic, The, in art. 2. Art--Technique. I. Title.

N8217.F28N53 2005
751.45'493982--dc22 2005004428

Edited by Christina Xenos
Cover designed by Wendy Dunning
Interior design and production by Lisa Holstein
Production coordinated by Mark Griffin

Claudia Nice is a native of the Pacific Northwest and a self-taught artist who developed her realistic art style by sketching from nature. She is a multimedia artist, but prefers pen, ink and watercolor when working in the field. Claudia has been an art consultant and instructor for Koh-I-Noor/Rapidograph and Grumbacher. She also represents the United States as a member of the Advisory Panel for the Society Of All Artists in Great Britain.

She travels internationally conducting workshops, seminars and demonstrations at schools, clubs, shops and trade shows. Claudia also has her own teaching studio, Brightwood Studio <www.brightwoodstudio.com>, in the beautiful Cascade wilderness near Mt. Hood, Oregon. Her oils, watercolors and ink drawings can be found in private collections across the continent and internationally.

Claudia has authored eighteen successful art instruction books, including *Sketching Your Favorite Subjects in Pen & Ink*, *Creating Textures in Pen & Ink With Watercolor*, *Painting Nature in Pen & Ink With Watercolor*, *Painting Weathered Buildings in Pen, Ink & Watercolor*, *How to Keep a Sketchbook Journal* and *Painting Country Gardens in Watercolor, Pen & Ink*, all of which were featured in the North Light Book Club.

When not involved with her art career, Claudia enjoys gardening, hiking and horseback riding in the wilderness behind her home on Mt. Hood. She passes on her love of art and nature by acting as an advisor to several youth groups.

METRIC CONVERSION CHART

To convert	to	multiply by
Inches	Centimeters	2.54
Centimeters	Inches	0.4
Feet	Centimeters	30.5
Centimeters	Feet	0.03
Yards	Meters	0.9
Meters	Yards	1.1
Sq. Inches	Sq. Centimeters	6.45
Sq. Centimeters	Sq. Inches	0.16
Sq. Feet	Sq. Meters	0.09
Sq. Meters	Sq. Feet	10.8
Sq. Yards	Sq. Meters	0.8
Sq. Meters	Sq. Yards	1.2

A Note to My Readers

During the time I wrote this book, I was recovering from abdominal surgery and undergoing chemotherapy for cancer. I would like to express my thanks to all of you who wrote, e-mailed, and sent cards to encourage me. It helped.

To those of you that are presently fighting, or have fought, life-threatening diseases, I dedicate this book. I empathize with your suffering and offer these words of encouragement, "I put my life in the loving hands of my God and sent my mind elsewhere. When my hands were steady enough to work, I sketched and painted. When I was too weak to work, I thought about beautiful places and dreamed up fantasy folk . . . faeries, elves, and unicorns. In my imagination, I flew with them and romped with them in the forest. When it was time to re-create them on paper, I knew them well. I didn't dwell on the creepy characters, like ogres, until I was feeling much better. I found art and my vivid imagination a great therapy tool, along with faith, hope and determination."

I would also like to comment on some favorite tools and products I used in the writing of this book. M. Graham & Co. watercolors and acrylics remain a favorite of mine. I also enjoyed the Faber Castell Pitt artist pens and the Masquepen by Cruddas Innovations Ltd. (U.K.), which applies masking fluid for watercolor with no mess. I do not represent these companies, but highly recommend their products.

Best Wishes,

Claudia Nice

Claudia Nice

Table of Contents

Introduction

In the depths of a primeval forest there was a hidden glen. Sunlight filtered through the ancient maples, creating dappled specters to dance across the moss-covered floor. In the heart of the glen was a deep pool, so clear that the fish seemed to be swimming in glass. Colored stones lay at the bottom of the pool like a treasure chest of jewels, set afire by the kiss of noontide light. Birds called across the glen in sweet cadence, safely hidden in leafy boughs.

Then nature caught her breath. From the cover of velvet black shadows stepped an equine prince . . . a magnificent golden unicorn. Its mane, tail, and horn were the color of ivory. Its eyes burned amber. Silently, the graceful creature walked to the pool, arched its neck downward and drank the cold, crystal water. At that moment I plucked it from my daydreams and brushed it into reality.

Art is the creation of a form or image based upon reality mingled with the imaginative. When the artist merely wants to duplicate what he sees before him, it requires more skill than imagination. However, when the inspiration for art is born in the daydreams of the artist, imagination plays a very healthy role. I have little trouble dreaming up fanciful images. The problem lies in making them believable on paper or canvas. I need something concrete to look at, to get the forms, features, highlights and shadows just right. For instance, the unicorn below is sketched from a common brown horse. Superimposed over it is the image created in my mind's eye—the horn, the heavy mane and tail and the golden color.

This is what this book is all about. . .how to use real subjects to bring the museful creations of the mind into focus. I've had a lot of fun composing the fanciful characters illustrated on the following pages. There's a special childlike freedom that arises when the imagination is allowed to take flight. I hope this book inspires you, the reader, to undertake your own imaginative journey. May it be a help to you along the way.

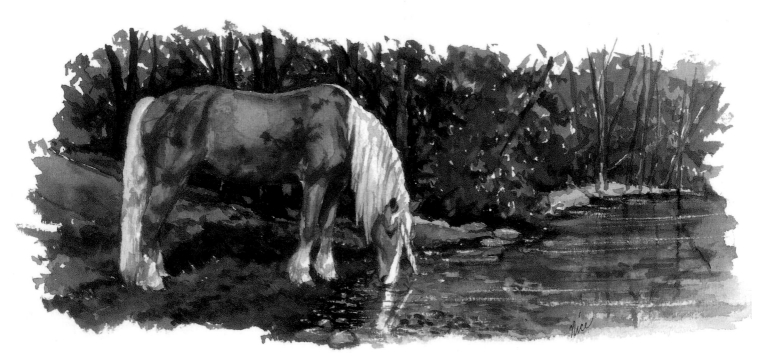

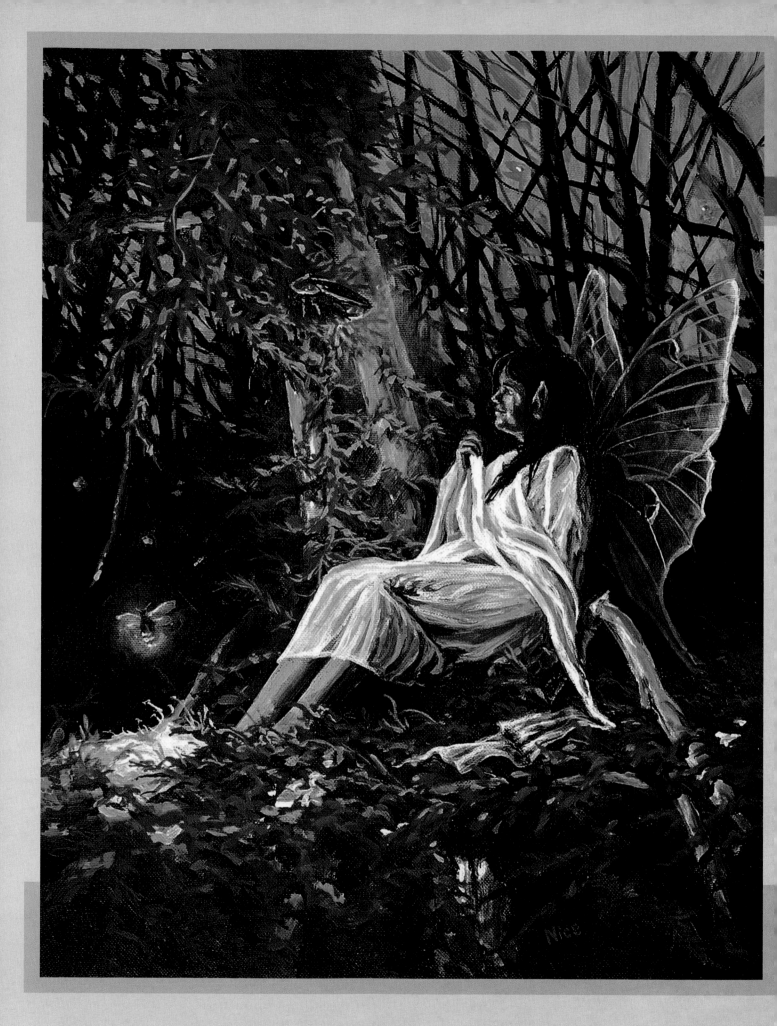

CHAPTER 1
Faery Folk

Once upon a time, in an age when sorcery and magic were common, belief in small, supernatural creatures was strong. Faeries, leprechauns, pixies, sprites, etc., interacted with mankind in secretive, magical ways. Much that could be explained in no other way was attributed to the wee folk. The tiny, winged beings were referred to as fay or faeries. This chapter is dedicated to them and their cousins the sprites. Out of respect for the days of yore and those who believed the strongest, I have maintained the archaic spelling of faery throughout the book.

Do I believe in faeries? I have yet to see one, but in my imagination they are very much alive. I was introduced to the world of faeries in the books my mother read to me and the stories she told. They became even more of a reality at the Camp Fire Girl's camp I attended each summer. I was introduced to Wah Wah Tay See, the firefly faery, who was responsible for making flashlights go dead if you used them inappropriately during council fire or shined them rudely in other people's faces. If you were very quiet after lights out at night, you might be able to hear the faeries sing. All the campers knew that you must never rest your elbows on the table at meal time or you risked squashing the invisible grace faeries who presided by your plate. In my minds eye, I can still see these fay and many others.

I have painted Wah Wah Tay See (opposite page), bringing her forth for others to enjoy. She is a princess, reigning over a nocturnal realm of fantasy. Her luminous subjects, the fireflies, bathe her in a glow that was considered magic by the ancients.

In this chapter, I have shown ways to turn people, insect wings, and fish fins into faeries and water sprites. Until I come face-to-face with a faery or a sprite swimming in a quiescent pool in some shady glen—it will do.

Wah Wah Tay See
Acrylic
8" × 10" (20cm × 25cm)

A tiny Grace Faery

Fantasy has its roots in reality, therefore it is wise to become familiar with the basic human figure before attempting to draw imaginary creatures.

Consider the skeletal drawing on the right. The better you know the innerworkings of the body, the more comfortable you will be drawing it.

The chart below shows the average proportions of the human body. If the adult figure were divided into six equal parts, the midway mark would be near the base of the trunk. The head takes up one-sixth of the height of the body and the legs approximately one-half.

I begin my figure drawings by roughing in the torso area. It helps to visualize the trunk as two trapezoid-shaped building blocks which are hinged at the waist.

Circles and elongated ovals make up most of the rest of the body contours.

Even when fully extended, arms and legs are not straight.

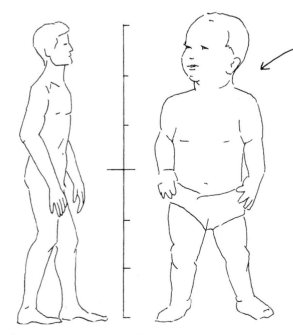

In young children, the body proportions are different. The head is longer and the arms and legs are shorter.

When the body is turned, the sides of the trapezoids must be added to give the body proper dimension. Note that the blocks are at slight angles to one another.

One must **see** the subject clearly with an artist's eye in order to draw it accurately. A straightedge (ruler, pencil or stick) is quite useful in enabling the artist to comprehend angles, curves, comparitive sizes and the proper placement and alignment of shapes. Compare the red angle lines that are drawn on the subject and figure no. 1. The upper back of figure no. one crosses over the red line, making it easy to see the back is too steep.

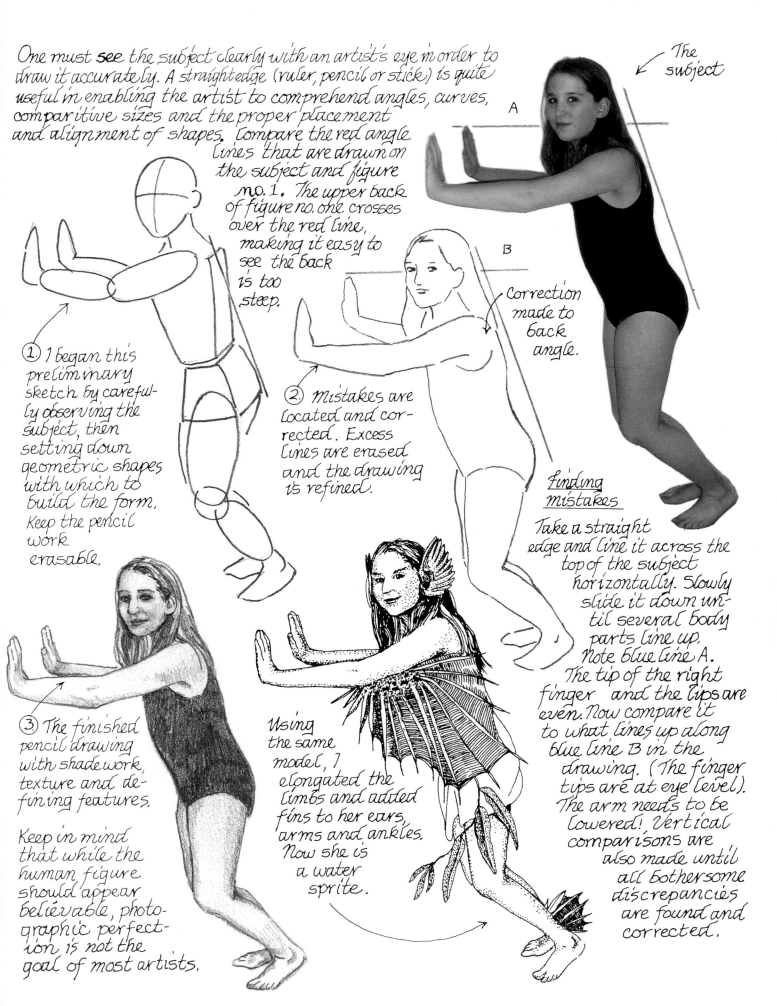

The subject

A

B

Correction made to back angle.

① I began this preliminary sketch by carefully observing the subject, then setting down geometric shapes with which to build the form. Keep the pencil work erasable.

② Mistakes are located and corrected. Excess lines are erased and the drawing is refined.

finding mistakes

Take a straight edge and line it across the top of the subject horizontally. Slowly slide it down until several body parts line up. Note blue line A. The tip of the right finger and the lips are even. Now compare it to what lines up along blue line B in the drawing. (The finger tips are at eye level). The arm needs to be lowered! Vertical comparisons are also made until all bothersome discrepancies are found and corrected.

③ The finished pencil drawing with shade work, texture and defining features.

Keep in mind that while the human figure should appear believable, photographic perfection is not the goal of most artists.

Using the same model, I elongated the limbs and added fins to her ears, arms and ankles. Now she is a water sprite.

The Face

There is a basic proportional arrangement to the features of the human face. Allowing somewhat for individual differences, here's how it works:

The eyes are located halfway between the crown and the chin. (A)

The eyebrows are placed approximatly an eye's width above the center point of the eye.

The bottom of the nose is positioned halfway between the eyebrows and the chin.

The mouth is one-third the distance from the nose to the chin.

If you wrap two contour lines around the head, running from the eyebrows and the bottom of the nose, you will discover that the ears fill the space in between. (B)

Crown

Eye level — A

B

Chin

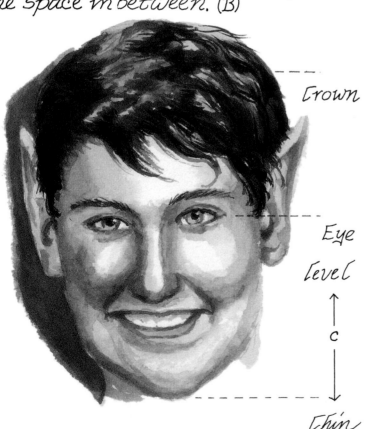

Crown

Eye level

C

Chin

Although faery folk may be depicted simply as human faces with large pointed ears, it's fun to experiment with re-proportioning the features. Some really interesting and creative characters will emerge.

In the illustration to the left, I kept all the face proportions the same above the nose, but lengthened the nose itself and the chin below. Note how much longer space (c) is, than the space between the crown and eyes. The ears were greatly enlarged and pointed. These simple changes turned the boy into a strong-jawed elf.

Skin

The keys to depicting realistic skin are color and texture.

My basic skin tone color formula is as follows: Burnt Sienna plus a touch of Quinacridone Rose to give it a healthy blush. I mute it down and create shadow tones by adding Sap Green. Add water or white if you're working in acrylic to achieve the lighter skin values.

I imagine the faery folk are a bit chameleon-like, adapting their coloration to their surroundings.

Pen and ink texturing

Base color

Burnt sienna plus Rose.

Sap Green and water added.

More Sap Green added and less water, creates shadow tones.

Watercolor glazes.

Soft, blended edges denote rounded contours.

Hard edges suggest abrupt angles.

Contour lines are varied length, smoothly drawn marks that seem to wrap around the surface of the object they are depicting. They work well to suggest skin.

Short, _crisscross lines_, set down side by side, at slightly different angles, can be used to depict beard stubble.

Beard stubble

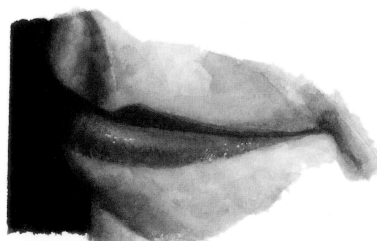

Male features are more angular.

Female features are more rounded.

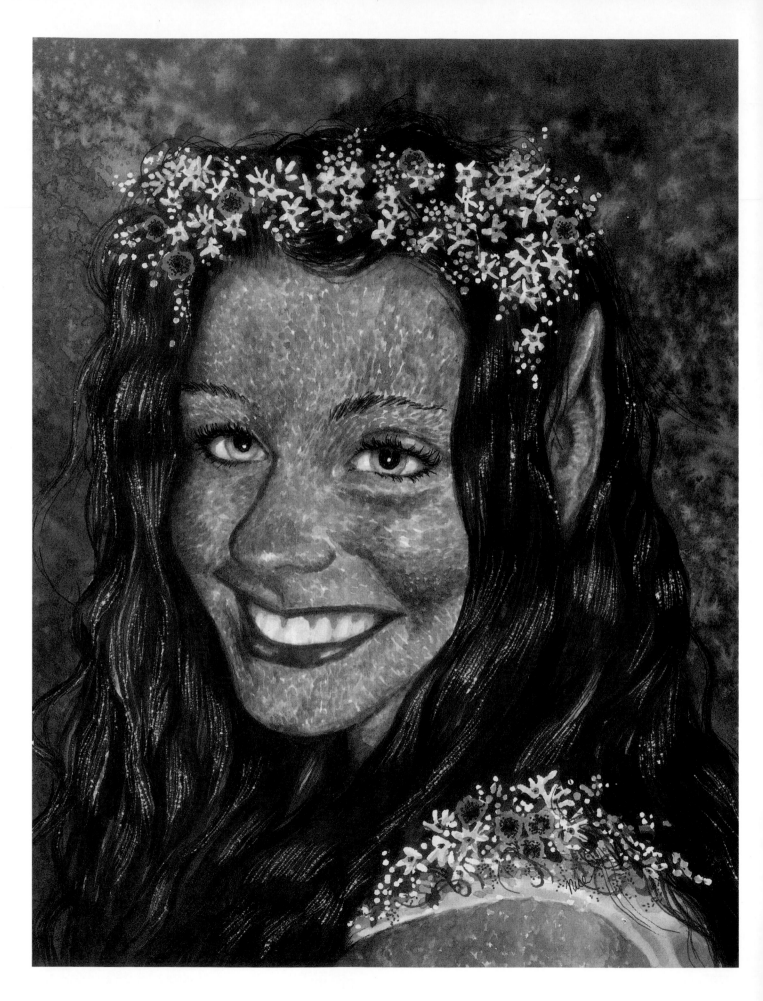

Chelsea's exotic eyes, captivating smile and thick, wavy tresses caught my eye as a faery model.

I wanted to paint her pretty much as I photographed her, yet add a sylphine quality to her likeness. The solution I came up with was to coat her skin with tiny, shimmery butterfly scales. They would camouflage her so well in the ferny glens that she would be all but impossable to see.

(Opposite page) - Butterfly Faery, 8" x 10" (20cm x 25cm) A watercolor painting. Masking fluid was used to block out the flowers in the hair. The textured background was created by spattering water drops into the wet paint.

Butterfly scale skin ~

① Make a fleshy brown color mix. (Burnt Sienna with a touch of Quinacridone Rose and Sap Green added.)

② Use daubing strokes and a small, blunt round brush to apply the paint over the skin areas. Use a darker mix in the shadow areas. Note white spaces left between the strokes. Let dry.

Sap Green

Hooker's Green plus Thalo Blue

Hooker's and Sap Green mix.

Hooker's Green

③ Prepare several green and blue-green washes on the palette. The paint should be thin enough to allow the brown to show through, when applied as a glaze.

④ Daub the greens and blue-green mixtures randomly over the brown undercoat, changing colors often. Use darker shades in the shadow areas. Allow some white to show through.

Ears

Elongated, pointed ears are a traditional feature of the faery folk. They are not hard to create using human ears as a base.

Begin by studying the ear and its many folds and contours. Become familiar with its basic shape.

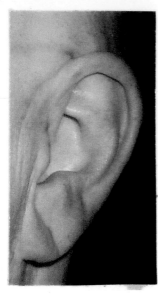

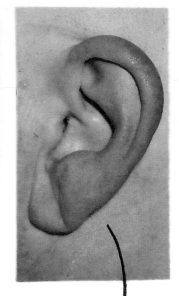

① Elongate the ear by extending the helix (top portion of the ear) upward into a nicely rounded, fleshy point. Make it as tall and wide as your imagination dictates.

Helix →

Contour pen lines smoothly follow the folds of the ear. →

② The ear lobe can be extended also.

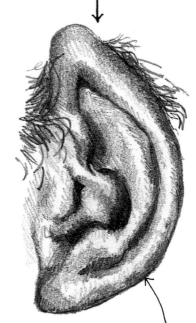

Not much elongatu on this pencil drawn ear, just a nice point at the top.

Add an earring if you like. This one is a gold nugget.

③ The result is a pixie ear finished with colored pencil.

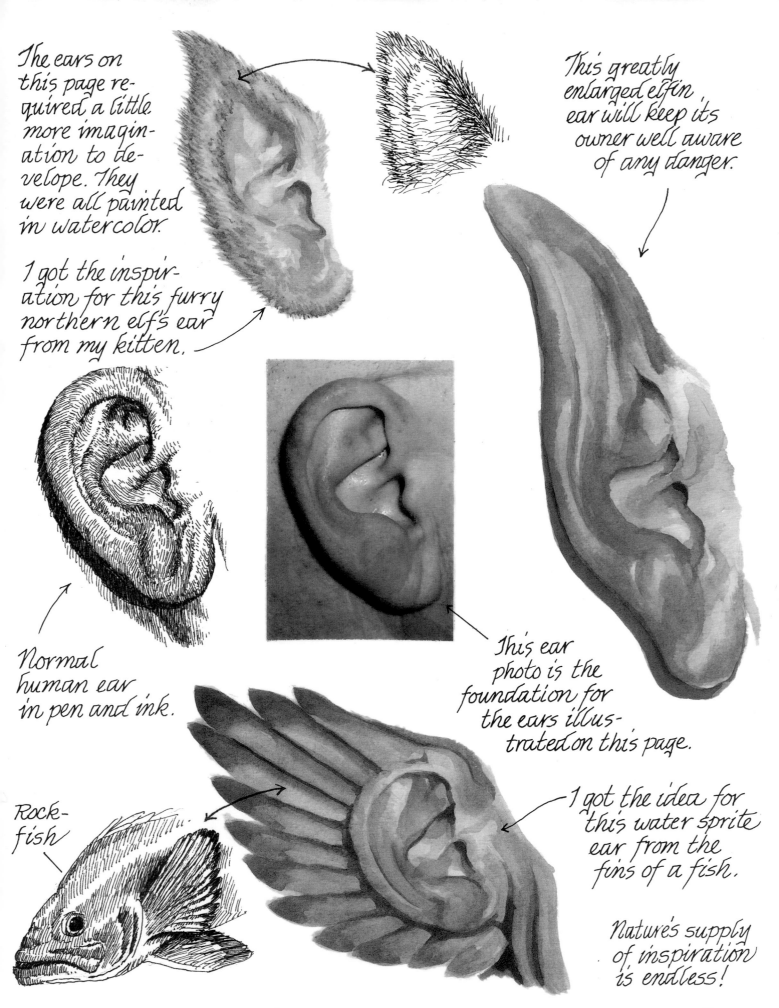

The ears on this page required a little more imagination to develope. They were all painted in watercolor.

I got the inspiration for this furry northern elf's ear from my kitten.

This greatly enlarged elfin ear will keep its owner well aware of any danger.

Normal human ear in pen and ink.

This ear photo is the foundation for the ears illustrated on this page.

Rock-fish

I got the idea for this water sprite ear from the fins of a fish.

Nature's supply of inspiration is endless!

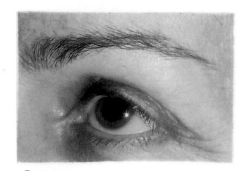

Illumination crescent (opposite highlight.)

Nib size .25 mm.

Eyes

I imagine faery folk eyes look very similar to human eyes in their basic shape, and in the way they catch and deal with light. Strong light enters the orb at a point closest to the source (highlight) and spreads out to create an area of lighter color (illumination crescent).

Highlight

Sparkle from gathered moisture.

This young woman was photographed outside on an overcast day. The lighting produced a mirror-like reflection across her eyes instead of highlight dots. The illumination crescent is absent. I added a bit of one anyway to bring out the color of her eyes in the painting below.

Watercolor

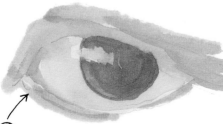

①. Preliminary washes are laid down and allowed to dry.

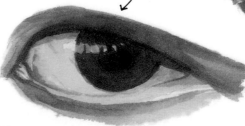

② Glazes (thin washes) are added to deepen color and create contour shadows.

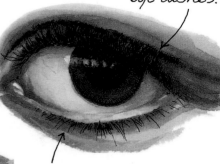

Pen and ink eye lashes.

③. final details are applied.

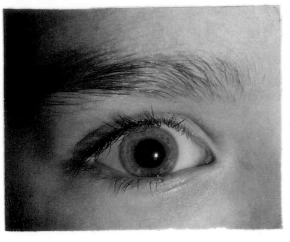

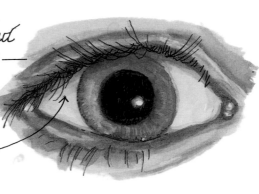

Watercolor with pen and ink lashes. —

shadows added

As you can see in the above photo of a young girl's eye, flashbulbs can wipe out the contour shadows and flatten the features. To make the eye orb look round again, add shadows to the recessed portions.

Don't be afraid to experiment with color.

— This camouflage coloration rendered in colored pencil will keep the faery well hidden in her ferny forest glen.

Pen and ink drawing using a .25 mm nib. Criss-cross lines make wonderful bushy eye brows.

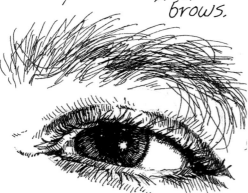

Adult male

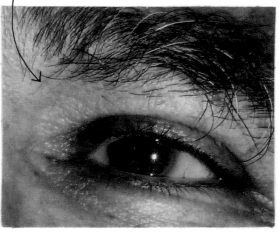

③ Details are added and deep shadows are darkened. The crucial white highlights are laid into place.

② Shadows are worked in using a layering technique.

Acrylic

① Basic colors are blocked in.

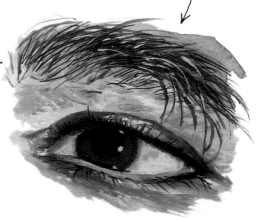

Faery Wings

Being delicate creatures, faeries require little in the way of wings to allow them to fly. The wings of butterflies and moths do nicely as examples to follow when working on a faery illustration. The examples on this page will give you a basic introduction to Lepidoptera wing structures, shapes and coloration.

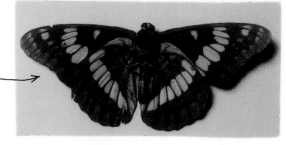

Lorquin's Admiral butterfly (underside)

The wings consist of a membrane stretched tight between rigid veins.

fore wing

Hind wing

Tiny dust-like scales coat the wings and give them shimmering color.

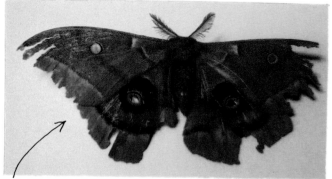

A Polyphemus moth with badly tattered wings. I imagine when faery wings are torn, new ones are grown. It probably involves special herbs, a bit of magic and a period of hibernation.

colored pencil

Tiny brush tip dots.

This is a "mock" Western Tiger Swallowtail butterfly. The wings are cut out of watercolor paper. The body is hot glued.

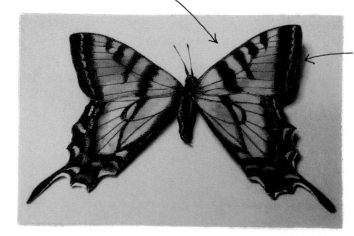

Cynthia Moth (watercolor)

Before the wings were cut out, they were painted with watercolor washes and textured with pen and ink dots. The veins are outlined with sepia ink. (.25 mm nib)

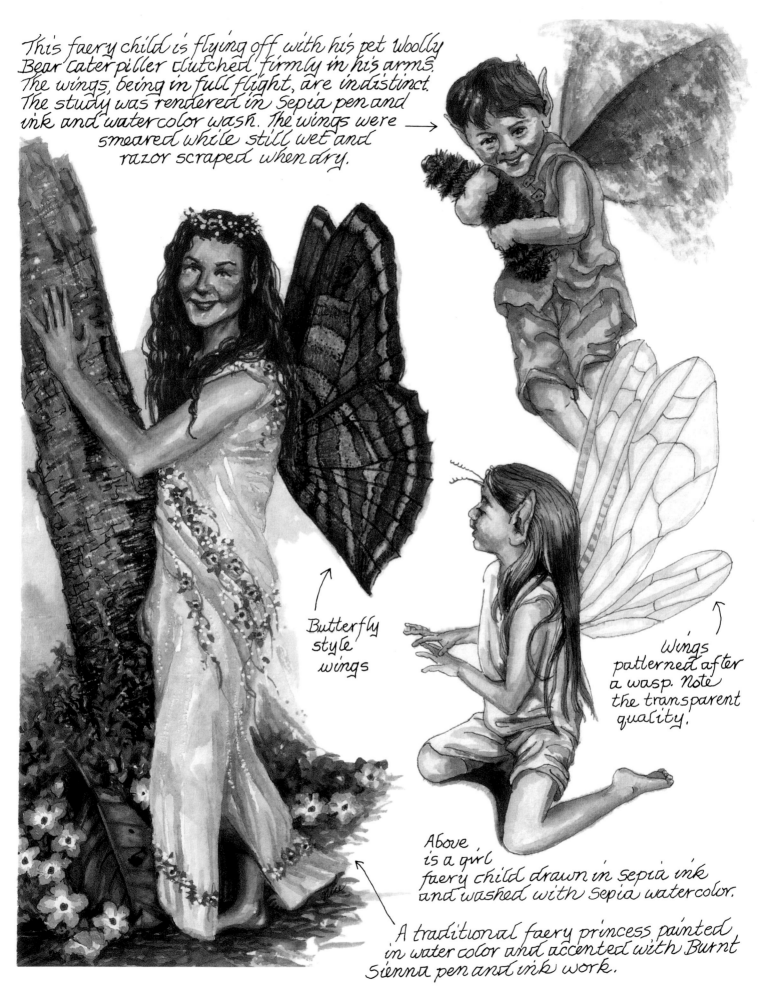

This faery child is flying off with his pet Woolly Bear caterpiller clutched firmly in his arms. The wings, being in full flight, are indistinct. The study was rendered in Sepia pen and ink and watercolor wash. The wings were smeared while still wet and razor scraped when dry. →

Butterfly style wings

Wings patterned after a wasp. Note the transparent quality.

Above is a girl faery child drawn in sepia ink and washed with sepia watercolor.

A traditional faery princess painted in water color and accented with Burnt Sienna pen and ink work.

Acrylic paint is the perfect medium for depicting transparent wings in color. Its opaque quality readily allows light colors to be layered over dark hues, and even thin washes show up.

① Begin by painting in the background. Simple shapes and dark colors work best to set off the wings.

② Sketch out the wing design and transfer it to the painting.

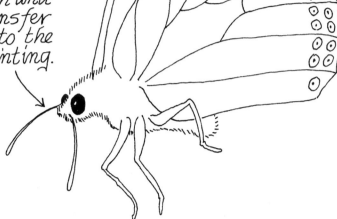

③ Use a no. 4 round detail brush and pale paint to outline the wings and veins. Add spots as desired.

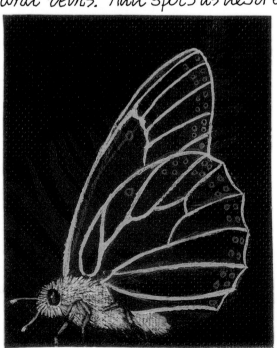

④ Thin the outline color to a wash and paint it over the entire wing.

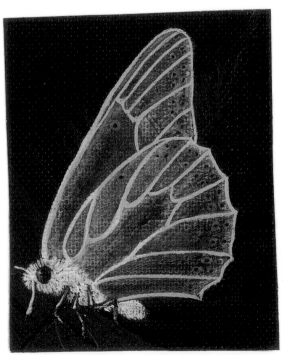

This type of wing is not too delicate for faery folk who use magic to help them fly.

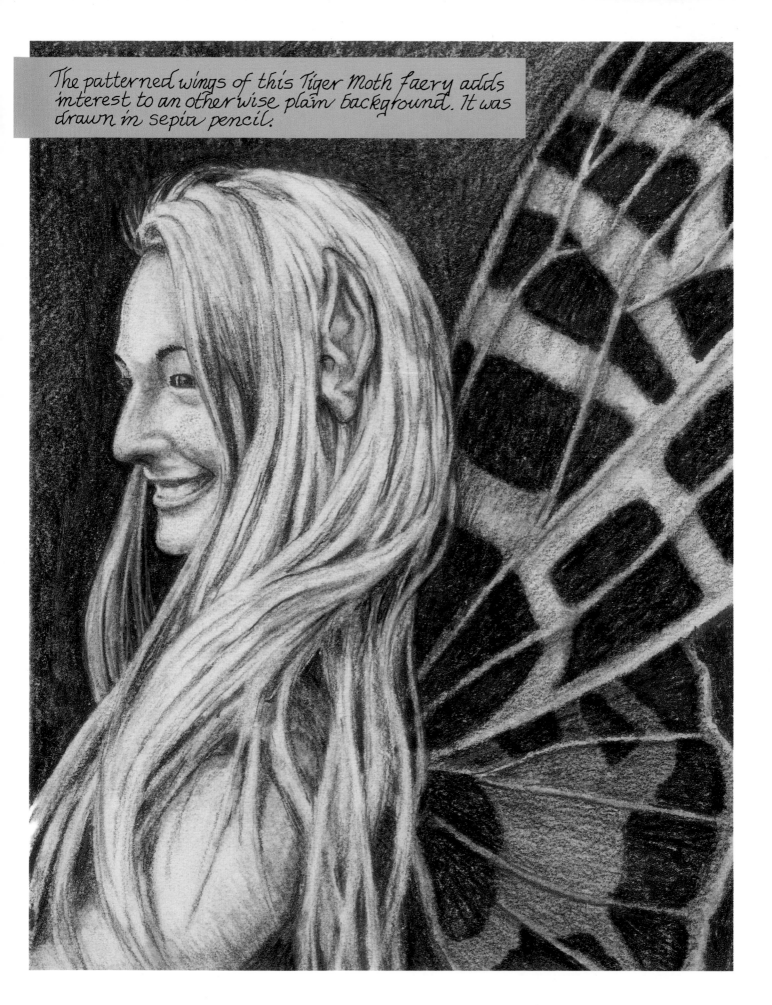

The patterned wings of this Tiger Moth faery adds interest to an otherwise plain background. It was drawn in sepia pencil.

Faery Clothing

The faery folk are clever creatures, skilled in the gleaning, spinning and weaving of raw fibers into beautiful textiles. I imagine they make good use of cocoon and spider web silk, and the fluffy down from dandelion, cotton-wood, thistles, milkweed, and cattail.

The wee ones know the art of flower drying, using a process that preserves the plants color, shape and elasticity. Leaves and blossoms are used for hats, vests, and decoration. They also make use of downy bird feathers and the wool, cast off from animals during the spring shed.

The collar is made from dried forget-me-not flowers.

A silk weaver faery at her loom.

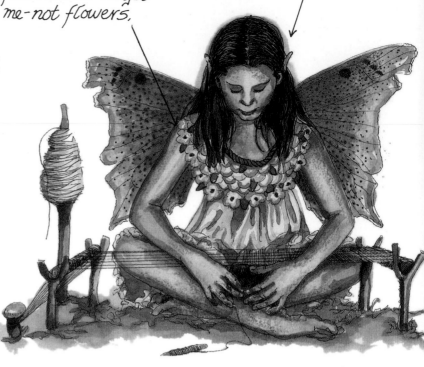

Faery clothing is low cut in back to accomodate their wings. It is fastened at the nape of the neck with tiny tie strings.

I imagined this gown to be made of gossamer web silk, trimmed with blue jay down.

Dried ivy hat.

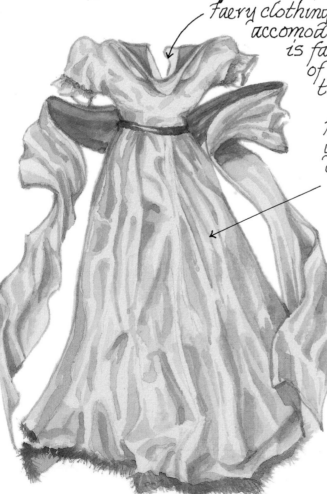

This is male foraging attire. The undershirt is woven from thistle down. The vest is made from a thick, wooly mullein leaf, and the trousers are wool, woven from the under-coat of a muskrat.

Accessories

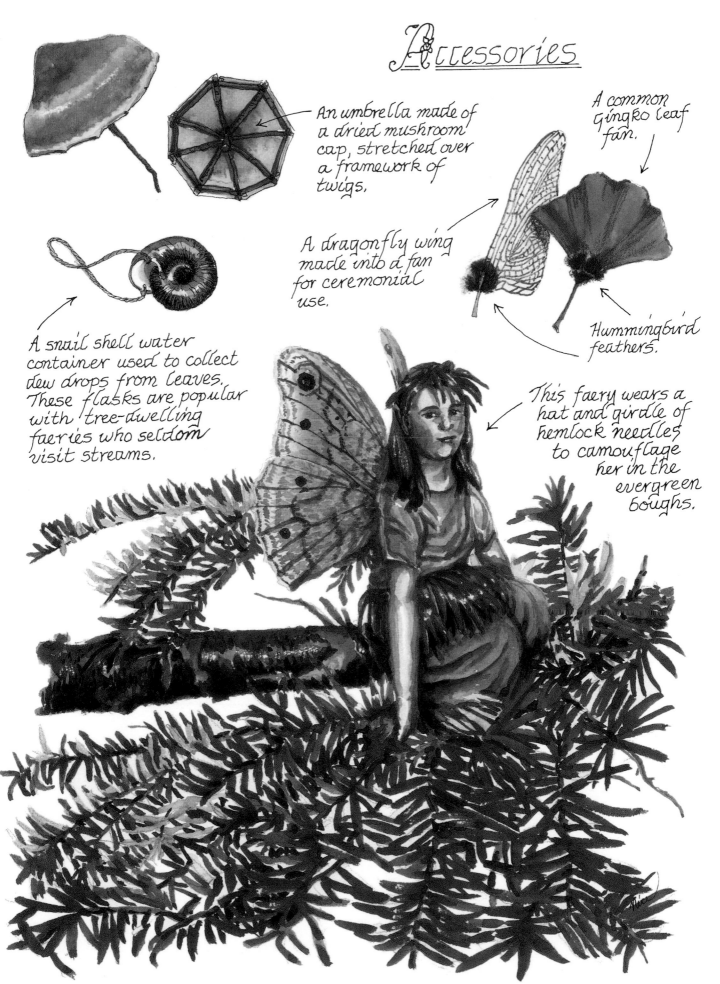

An umbrella made of a dried mushroom cap, stretched over a framework of twigs.

A common Gingko leaf fan.

A dragonfly wing made into a fan for ceremonial use.

Hummingbird feathers.

A snail shell water container used to collect dew drops from leaves. These flasks are popular with tree-dwelling faeries who seldom visit streams.

This faery wears a hat and girdle of hemlock needles to camouflage her in the evergreen boughs.

Faery Houses

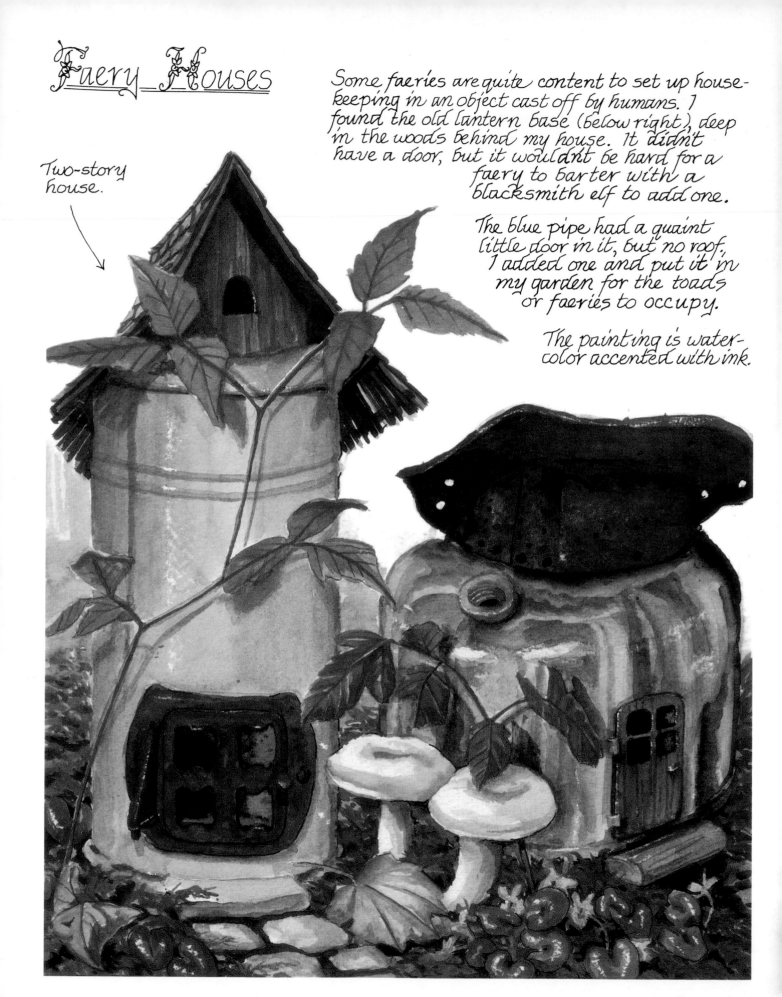

Some faeries are quite content to set up house-keeping in an object cast off by humans. I found the old lantern base (below right), deep in the woods behind my house. It didn't have a door, but it wouldn't be hard for a faery to barter with a blacksmith elf to add one.

The blue pipe had a quaint little door in it, but no roof. I added one and put it in my garden for the toads or faeries to occupy.

The painting is water-color accented with ink.

Two-story house.

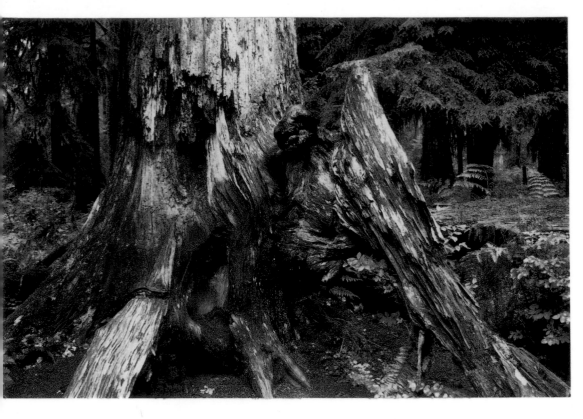

To the left is a rotten stump as seen through a camera lens.

Below is a pen, ink and wash diagram of the faery home hidden within the same stump.

The walls are whitewashed to magnify the light from the woodpecker hole windows and the faery lanterns.

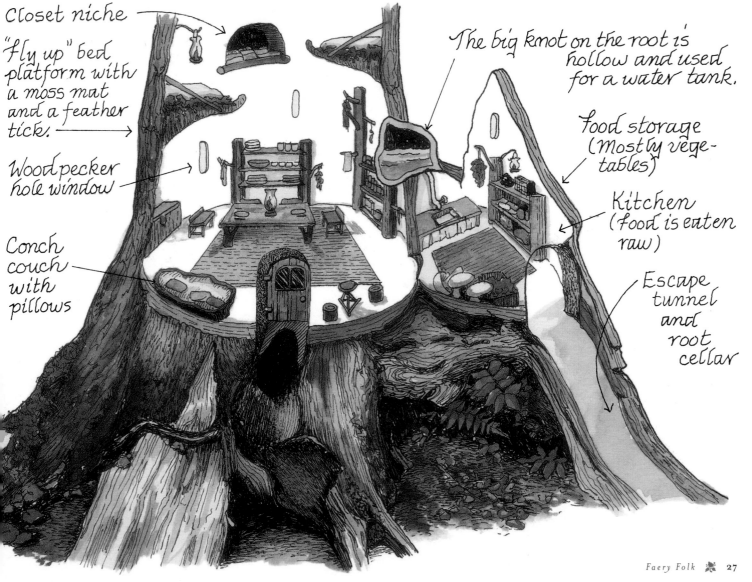

Closet niche

"Fly up" bed platform with a moss mat and a feather tick.

Woodpecker hole window

Conch couch with pillows

The big knot on the root is hollow and used for a water tank.

Food storage (mostly vegetables)

Kitchen (food is eaten raw)

Escape tunnel and root cellar

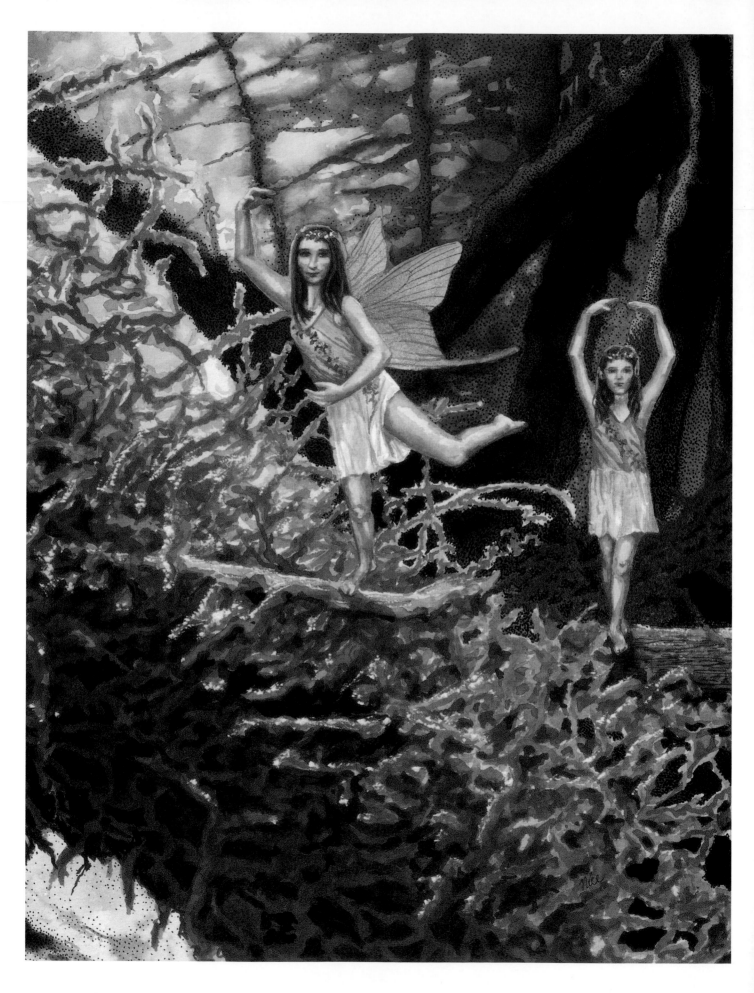

From Start to Finish

I call the watercolor painting seen on the opposite page – Ballet In The Boughs. 9" x 12" (23 cm x 30½ cm).

It began as an inspiration which came to me as I watched my granddaughter Mikaela perform at her dance recital. I wanted my faery dancers located in the tree branches as I imagined flight as part of their ballet.

Wings were added. In the painting I glazed them with Winsor & Newton Iridescent Medium to make them shimmer.

Quick study sketches

I chose this scene for my background because I liked the dramatic value contrast and the soft texture of the moss. In the painting I used pen and ink stippling to help darken the background.

The painting was planned 12" x 16" (30 cm x 41 cm) with three faeries. The pencil thumbnail sketch gave me an idea of how it might look. ———→

However, upon the painting's completion, I decided the background overwhelmed the subject. I cut it down to it's present size to zero in on the first two faeries. I like the overall effect better, but it really hurt to snip away all that stippling!

Removed area

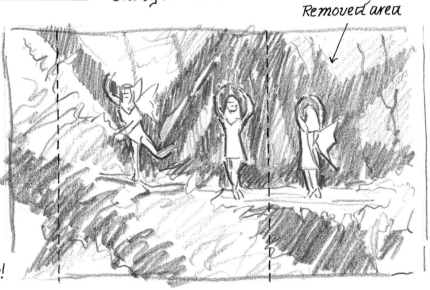

Woodland Faeries

Northwoods faeries grow peach fuzz fur in the winter to help keep them warm.

White moth wings.

Winter wear: Cattail fluff, wool and feather down hat.

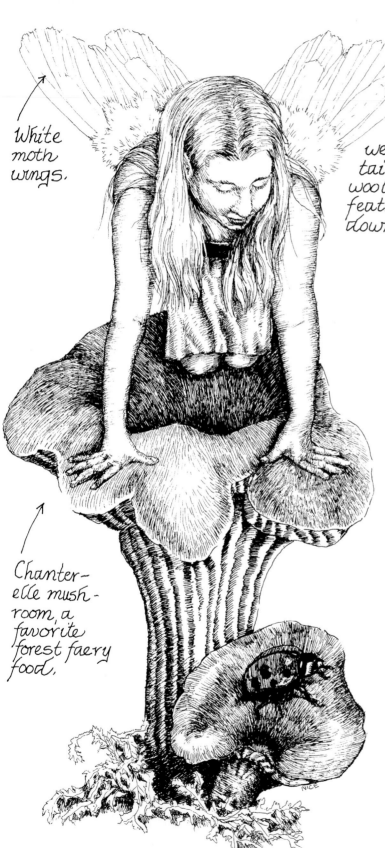

Chanterelle mushroom, a favorite forest faery food.

Opposite page: My Brother's Keeper ~ 8" x 10" (20 cm x 25 cm). The painting is watercolor. The wings, leaves, and pet tree frog are enhanced with colored pencil. I used masking fluid to mask out the white dot design on the dress. Burnt Sienna was mixed with Sap Green to create the olive brown camouflage color for the skin.

The brother and sister in the painting are swallowtail faeries. Little brother's wings have become tattered. He will soon go to bed for a molting sleep, during which he will shed his small, worn wings and grow new ones. Faeries are not born with wings but grow them in stages. The swivelling antennae on these faeries help them find flower nectar in the forest meadows and avoid the butterfly-eating birds.

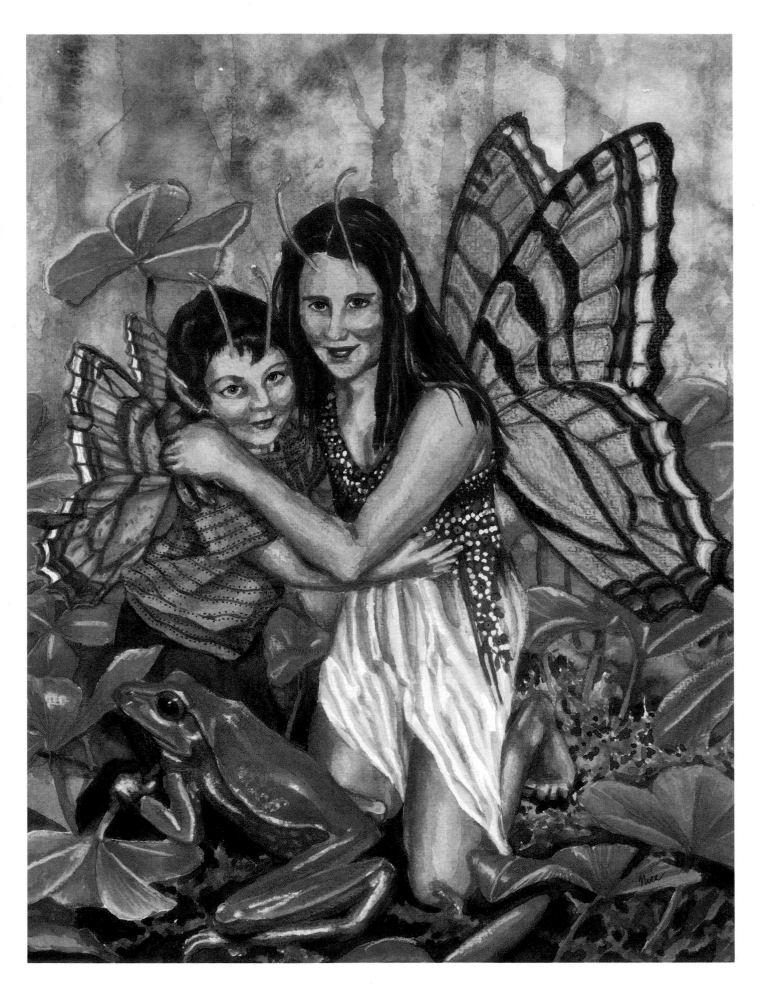

Garden Faeries

I imagine the faeries that live in the sunny domestic gardens are cultivators. They harvest and replant seeds. Often the seeds they sow are weeds, for they have uses for most all plants. Lady faeries collect and prepare bits of their favorite specimens to use for food, medicine, clothing, and trade. Various faery clans specialize in certain plant species. Their wings and coloration help disguise them when flitting among their chosen flora.

A shy member of the marigold clan.

All garden faeries dislike slugs. Should their delicate wings come in contact with slug slime, they are often rendered flightless until their next molt. Warrior faeries hunt slugs, stink bugs and other disagreeable pests using thorn-tipped spears.

Blue Gentian Faery

Opposite page:

Honey Bee Faeries - 8" x 10" (20 cm x 25 cm). Watercolor, pen and ink.

These lively, fun-loving faeries assist their namesakes in the collection of pollen. In return, they receive bits of honey comb. The two faeries in the painting are separating the sunflowers to allow the honey bees better access. Note the transparent, bee-shaped wings on the backs of the faeries, enabling them to fly rapidly.

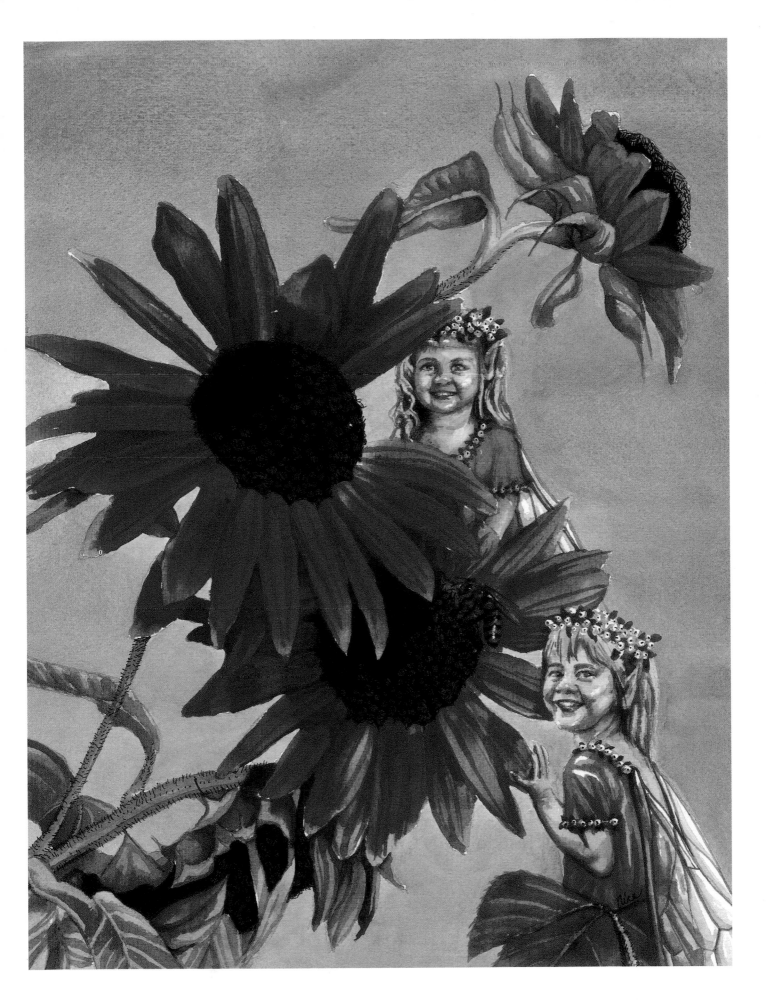

Water Sprites

Water sprites are amphibious fay that dwell in creeks, rivers, ponds, lakes, and even in the tidal zones of seas. They are shy, well-camouflaged and seldom seen. Tradition does not dictate exactly what water sprites look like, which allows the imagination to run free. My imagination used various fish and amphibians for inspiration.

Leopard frog ⟶

Painted turtle

Three-toed webbed feet.

A pond princess of the spotted frog-foot clan. These sprites are often mistaken for startled frogs when they dive suddenly into the water.

Opposite page:
Deep Lake Sprite, 8" x 10" (20cm x 25cm) watercolor.

This deep water denizen has both gills and fins. Members of this sprite clan are fond of pranks. Their mischief may include snagging fish hooks in submerged stumps, emptying crawfish traps, poking holes in waders and setting boats adrift.

Like a chameleon this sprite is able to match her skin tone to her surroundings.

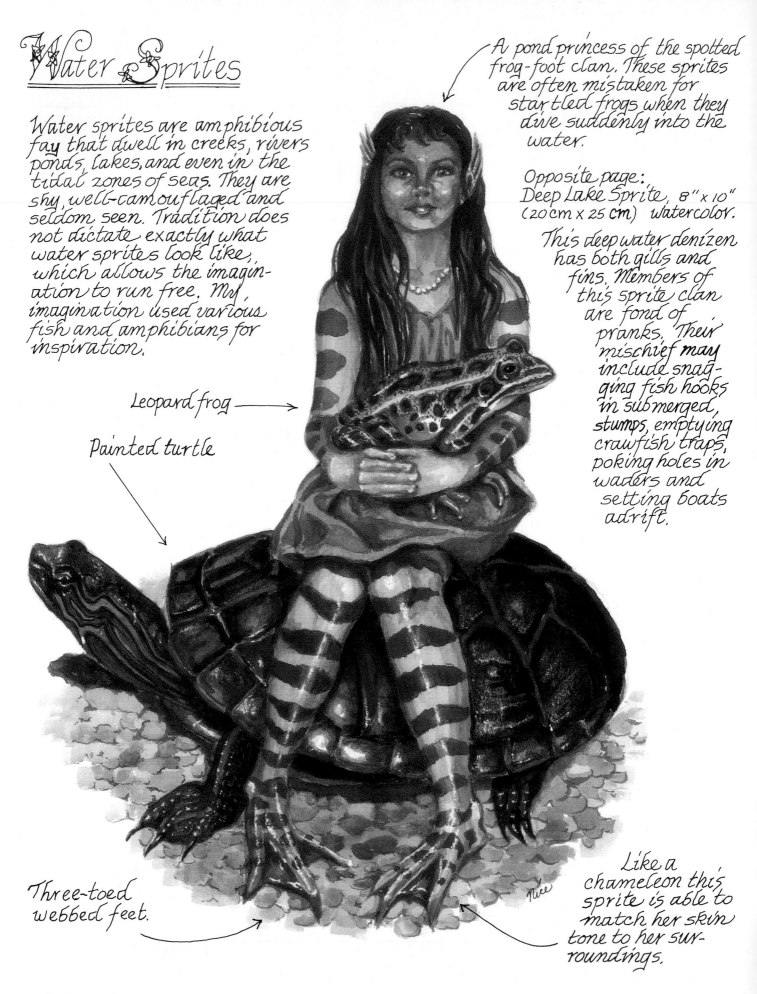

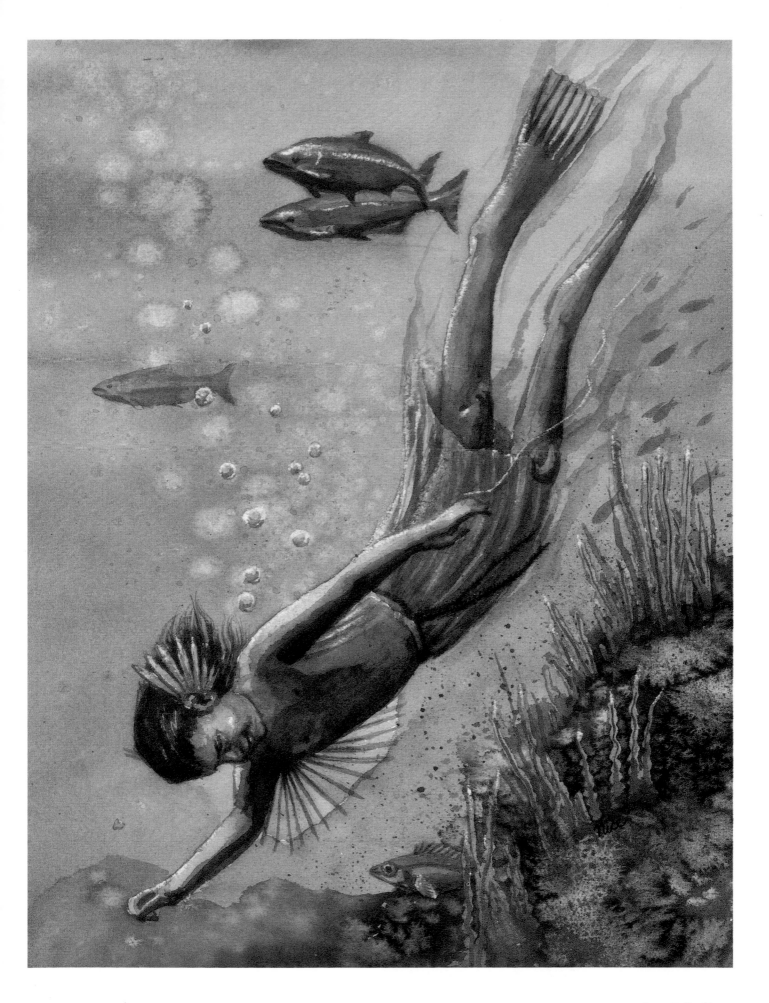

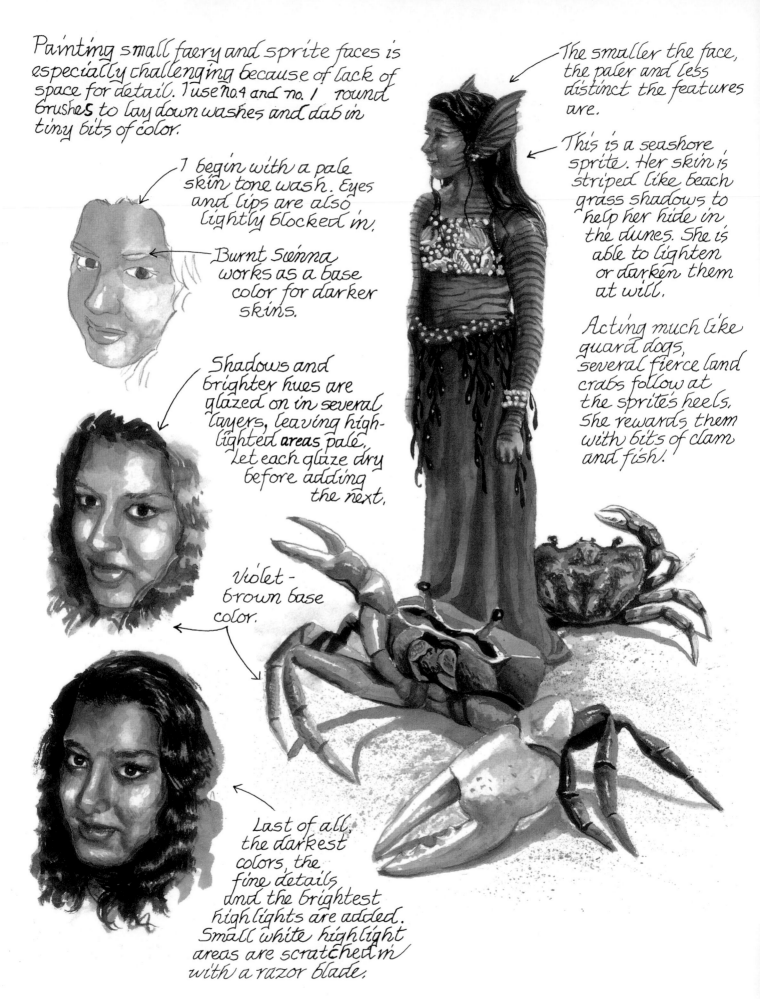

Painting small faery and sprite faces is especially challenging because of lack of space for detail. I use no. 4 and no. 1 round brushes to lay down washes and dab in tiny bits of color.

I begin with a pale skin tone wash. Eyes and lips are also lightly blocked in.

Burnt sienna works as a base color for darker skins.

Shadows and brighter hues are glazed on in several layers, leaving highlighted **areas** pale. Let each glaze dry before adding the next.

Violet-brown base color.

Last of all, the darkest colors, the fine details and the brightest highlights are added. Small white highlight areas are scratched in with a razor blade.

The smaller the face, the paler and less distinct the features are.

This is a seashore sprite. Her skin is striped like beach grass shadows to help her hide in the dunes. She is able to lighten or darken them at will.

Acting much like guard dogs, several fierce land crabs follow at the sprite's heels. She rewards them with bits of clam and fish.

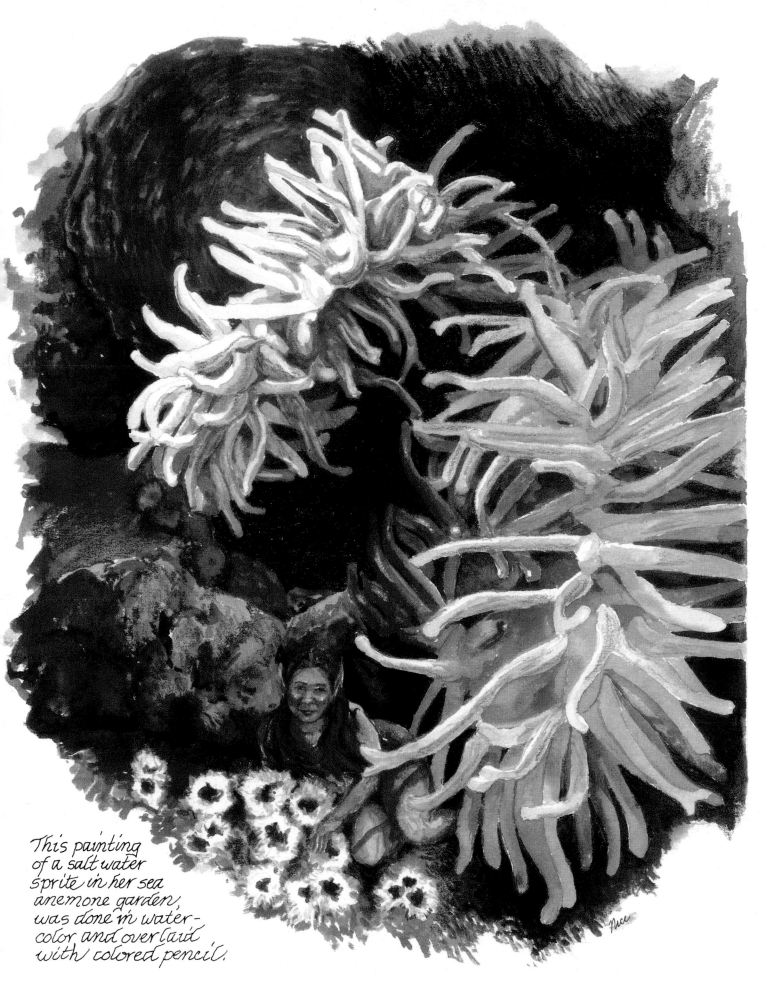

This painting of a salt water sprite in her sea anemone garden, was done in water-color and overlaid with colored pencil.

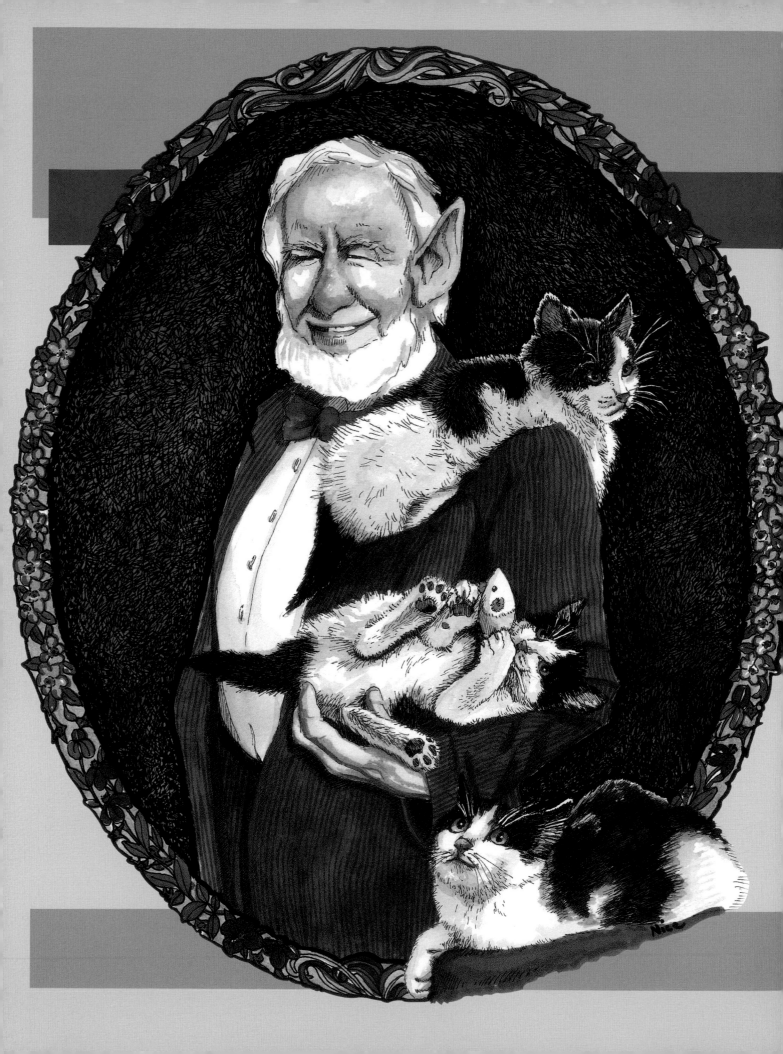

CHAPTER 2
Household Elves & Brownies

When I think of elves, I imagine an old Victorian house. It's night and the last member of the human household has gone to sleep. A curious light appears in the living room and as it drifts into the dining room a figure takes shape, clutching the light in its hand. The spry, bearded creature is almost the size of a small human with great pointed ears. He laughs as he reaches under the dining room table and scoops a playful kitten up in his arms. He finds two more in the kitchen and carries the trio to the parlor, where he gently deposits the kittens over the threshold. A sprinkle of pixie dust in the doorway keeps the mischievous cats from following him into the kitchen. Next the old one dances a jig to the pantry door, which he opens. A single tap on a glass jar with a spoon rings clear in the quiet house. The signal has been given. The jolly figure with the overgrown ears is an elf; a senior pantry elf, who makes the pantry safe for the smaller elves and brownies, who now come out to work, forage and trade in the shadows of the nightstill house. They are a fun-loving, good-spirited bunch, who aren't afraid to do a chore in return for the bits of food they will gather. Some live in the walls, while the larger ones live right beside the humans, shielded from view with a fog of invisibility. Each elf has a special skill and a role to play in the elfin colony. Most times what the elves do goes unnoticed by the human household. However, if the pantry door should be locked or the pantry contents be placed in sealed containers, the elves would be very miffed indeed. There is no telling what mischief they would cause in retaliation.

The illustration on the opposite page is of the Senior Pantry Elf clearing the kitchen of kittens. I sketched it in pen and ink and overlaid with washes of watercolor and colored Pitt brush tip pens. The border adds a festive mood. Elves are not hard to create. Find a photo or model with a twinkle of mischief in his or her eye and you're halfway there. This chapter will provide some step-by-step advice and plenty of examples to show you how fun it can be to dream up an elf.

Senior Pantry Elf
Pen, Ink and Watercolor
8" × 10" (20cm × 25cm)

Skin Wrinkles

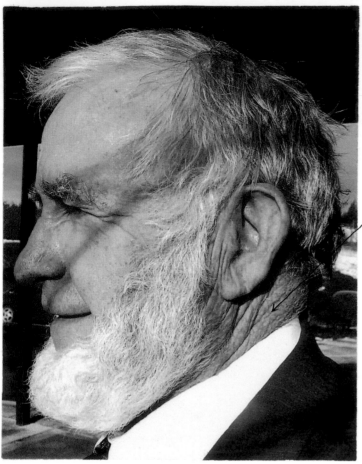

Elves mature quickly and live to be quite old. Their faces have great character with lots of skin folds and wrinkles.

For smooth wrinkles drawn in pen and ink, I usually use contour lines. With pen it's best to stroke across the lines of the wrinkle instead of the same direction. Use a .25mm nib or smaller.

The examples below are from the neck area of the photograph.

I found the perfect elf model in my friend Mr. Russell. He has some good wrinkles, a wonderful beard, a face with *mischievous* character, and nice, bushy eyebrows. Only the ears need changing.

Good example

Preliminary pencil guide-lines.

In these contour line wrinkles, each fold has a gradually darkened shadow side and an abrupt transition on the **highlight** side.

A bad example. The transition from light to dark is missing. The creases are too dark, making them look like scars.

Hatch marks Crosshatch

<u>Crosshatching</u> takes place when two or more sets of lines called hatch marks intersect at different angles.

Right angle cross-hatching is too bold for most skin types.

Crosshatching works well for portraying dark skins, rough skin, heavily shadow-ed areas, and for textured back-grounds and textiles.

Three line sets used.

<u>Watercolor</u>

I used glazing techniques, blending the edges where appropriate with a clean, damp brush while the paint was still moist. With paint I find it best to stroke in the direction of the creases.

Hair Textures

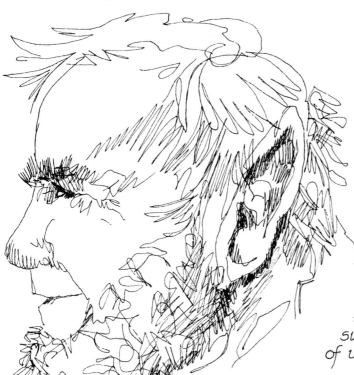

<u>Scribble strokes</u> are freely looping lines which are drawn in random directions. When used thickly, they have a matted or tangled appearance which is useful in depicting moss or foliage seen at a distance.

Controlled scribble lines can produce tight, kinky curls.

Loose, wiry strokes can suggest a patch of whisker hair.

The scribble technique is perfect for making quick, loosely drawn study sketches.

<u>Crisscross lines</u> are good for depicting straight hair. The strokes may be slightly curved, and are allowed to lay across one another in a natural hair-like pattern. The lines should lay against the skin or spring outward like vel-vet if very short. Longer hair strands should flow together smoothly, hanging downward or outward if wind blown.

Layered crisscross strokes worked in watercolor using a liner brush. The paler hues were applied first.

<u>Wavy lines</u> are drawn side by side, forming a loose, rippling pattern. They are useful in depicting locks of twisted hair, wood grain and feather barbs.

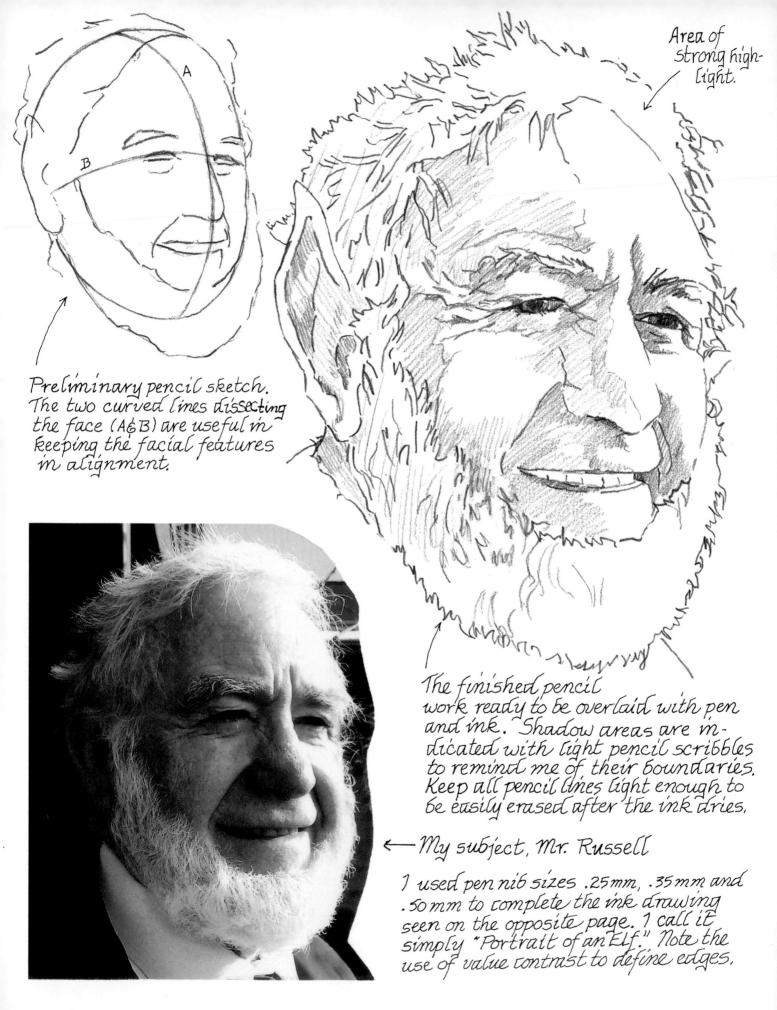

Area of strong high-light.

Preliminary pencil sketch. The two curved lines dissecting the face (A&B) are useful in keeping the facial features in alignment.

The finished pencil work ready to be overlaid with pen and ink. Shadow areas are in-dicated with light pencil scribbles to remind me of their boundaries. Keep all pencil lines light enough to be easily erased after the ink dries.

← My subject, Mr. Russell

I used pen nib sizes .25mm, .35mm and .50mm to complete the ink drawing seen on the opposite page. I call it simply "Portrait of an Elf." Note the use of value contrast to define edges.

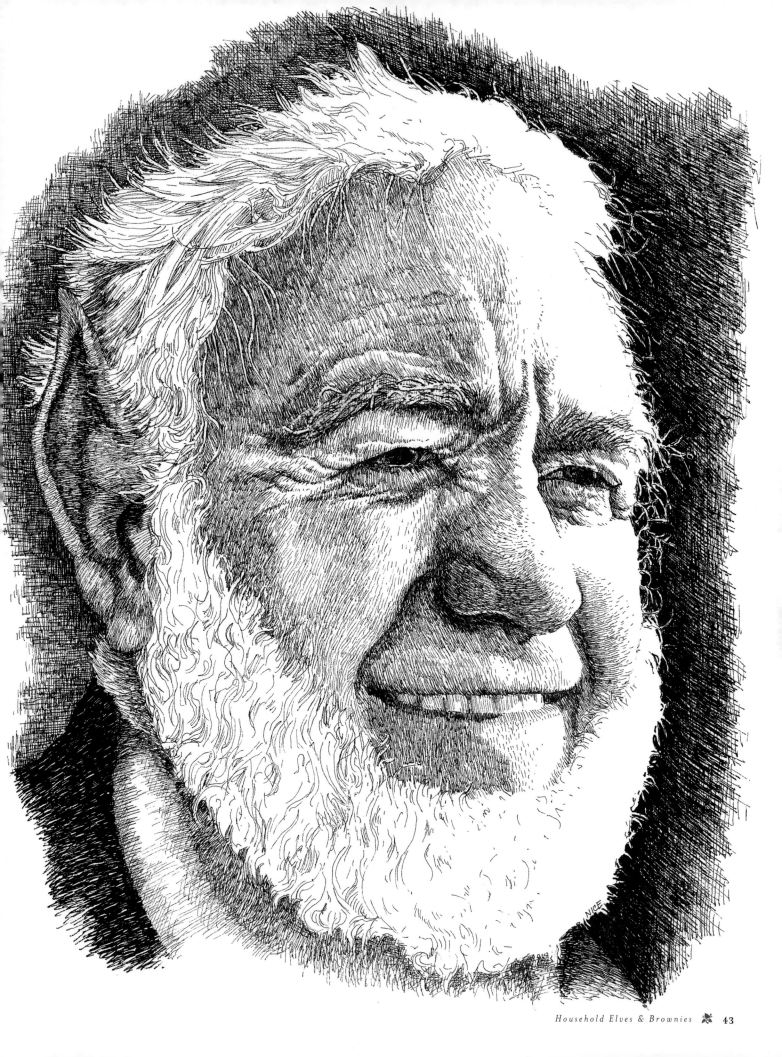

Changing the Features

Besides the obvious large pointed ears that all elves have, other facial features can be changed to make human models more elfin in appearance. The nose and chin can be enlarged or pointed. Eyebrows can be swept upward and made more bushy. If you want the elf to closely resemble the model, simply exaggerate the features a little instead of a lot.

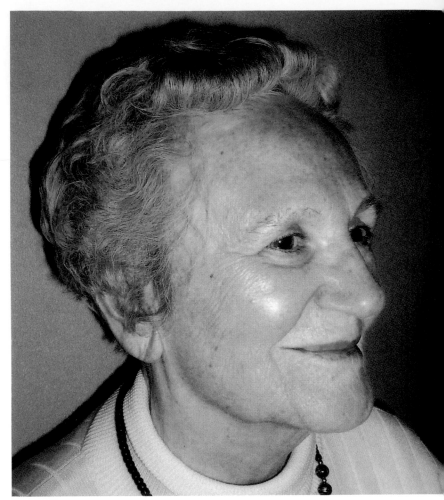

My model, Elda Monteith

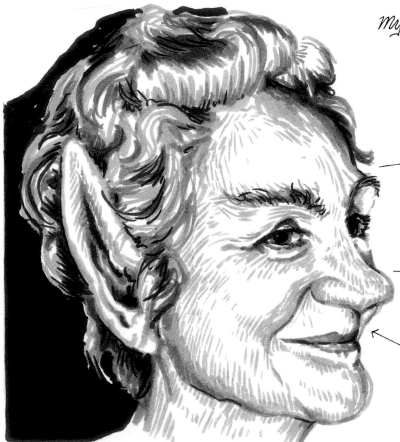

Eyebrows were made thicker and given an upward sweep.

Nose was made longer.

The sketch was made using a variety of PITT brush tip pens.

This .25mm pen and ink sketch started out with a pencil drawing patterned after the photo seen below. Before I added ink, I enlarged the nose, swept the eyebrows upward and made the ears huge and pointed. I then added the age spots, warts, and scraggly beard along with the ink texture lines. The hair sprouting from the ears was the final touch.

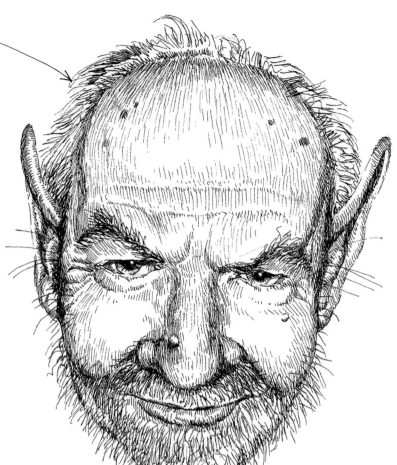

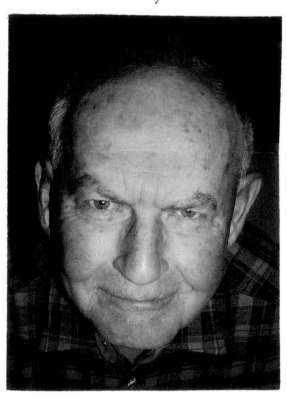

Rodney Salzer (My Dad)

Note cut out areas in the hat to make room for the elfin ears.

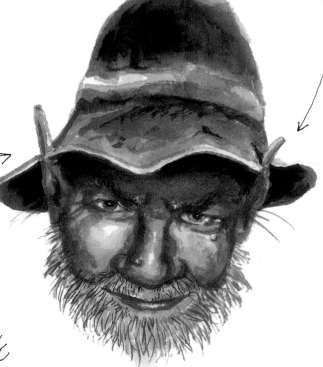

This watercolor study looks even less like the photo due to the addition of the hat and the shadows it cast. Remember, the idea was not to copy the likeness of a photograph but to use the model as a launching pad for the imagination. Whimsy and fun are just as important as skill in the creation of fantasy folk.

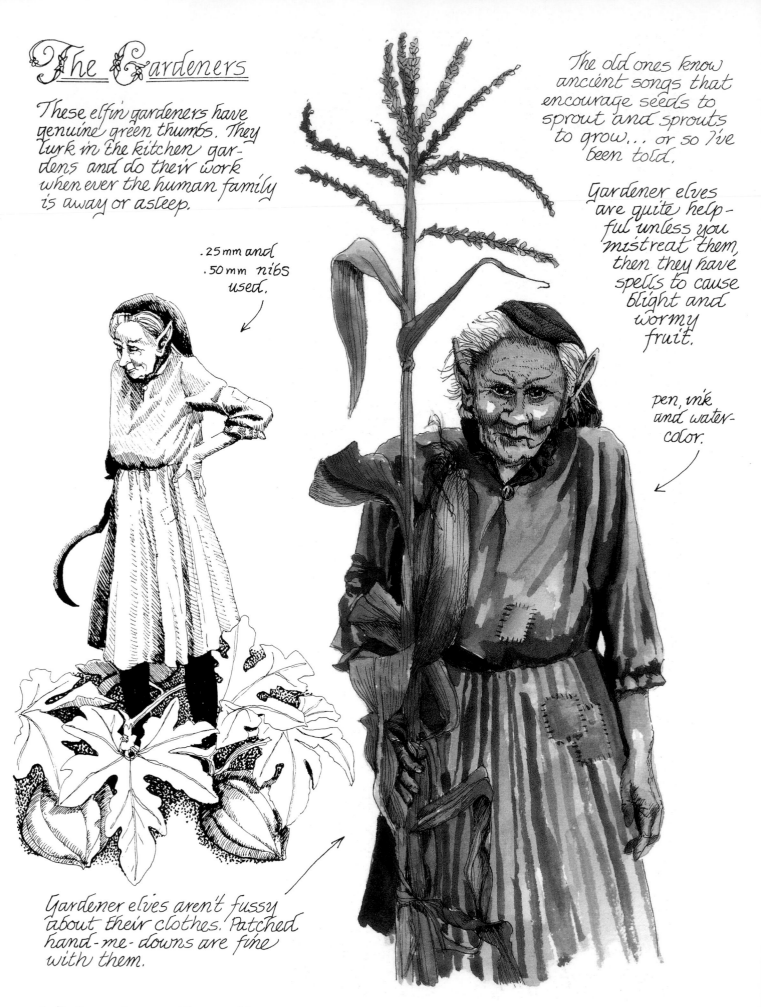

The Gardeners

These elfin gardeners have genuine green thumbs. They lurk in the kitchen gardens and do their work whenever the human family is away or asleep.

.25 mm and .50 mm nibs used.

The old ones know ancient songs that encourage seeds to sprout and sprouts to grow... or so I've been told.

Gardener elves are quite helpful unless you mistreat them, then they have spells to cause blight and wormy fruit.

pen, ink and water-color.

Gardener elves aren't fussy about their clothes. Patched hand-me-downs are fine with them.

In this watercolor illustration of a tomato patch, a wee brownie elf is on his way home to dinner. The cherry tomato in his collection bag is the main course.

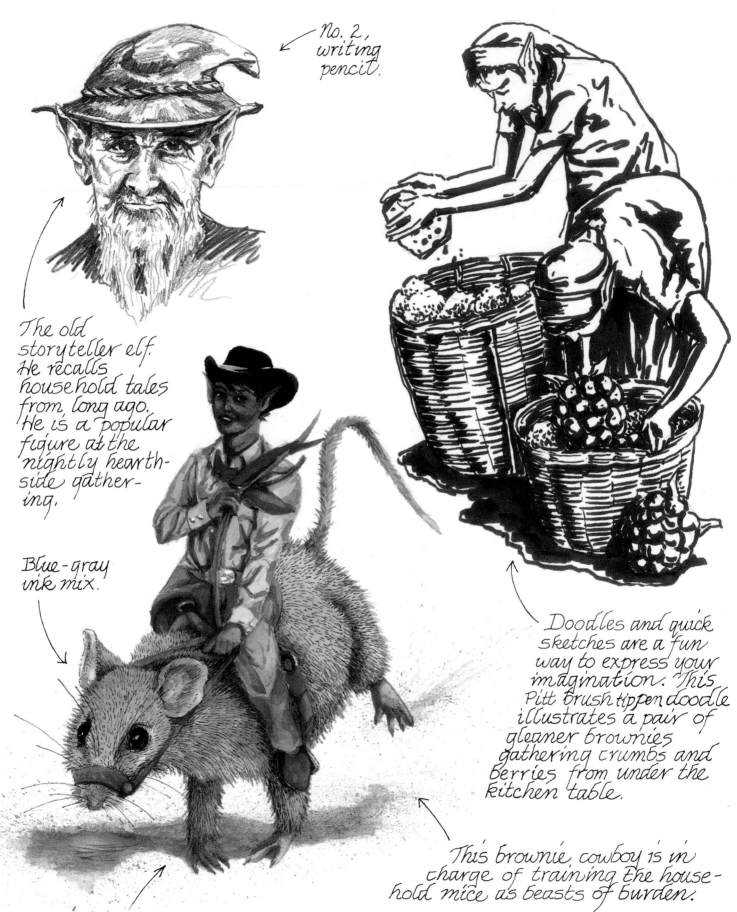

No. 2, writing pencil.

The old storyteller elf. He recalls household tales from long ago. He is a popular figure at the nightly hearthside gathering.

Blue-gray ink mix.

Doodles and quick sketches are a fun way to express your imagination. This Pitt brush tippen doodle illustrates a pair of gleaner brownies gathering crumbs and berries from under the kitchen table.

This brownie cowboy is in charge of training the household mice as beasts of burden.

Colored ink, overlayed with watercolor, provides a bright, illustrative look.

Cobbler elves earn their keep by making shoes for other elves and their faerie cousins. If they feel so inclined, they may make repairs on human foot-wear as the brownie cobbler, illustrated below, is doing.

This painting was done using washes of acrylic. I used mixtures of Burnt Umber, Raw Umber, and Mars Black.

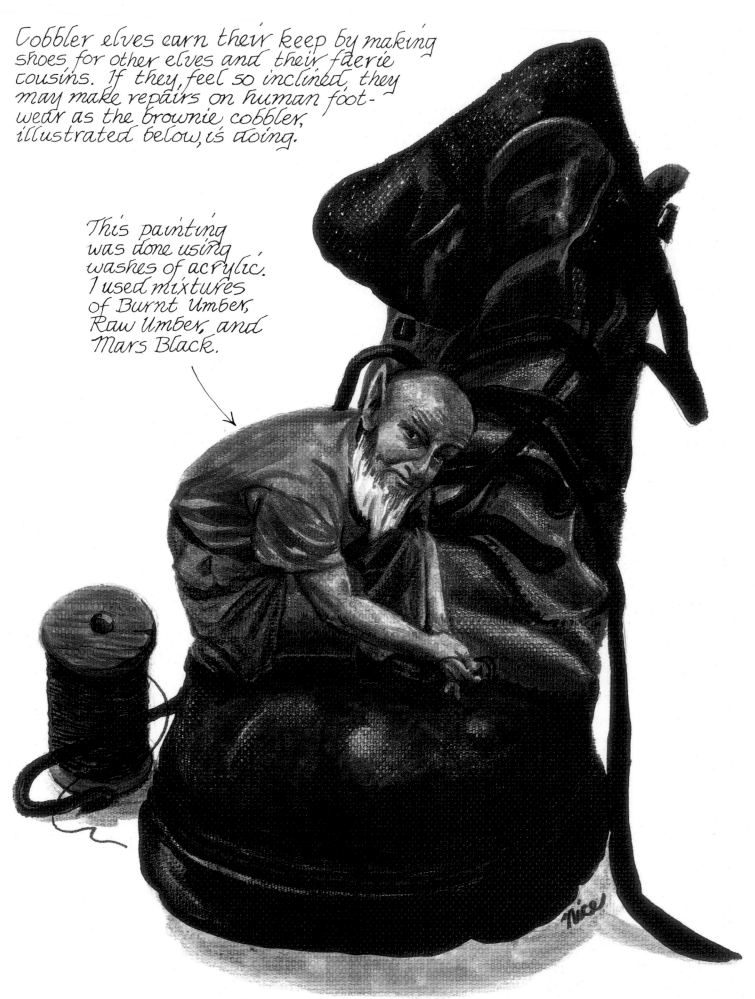

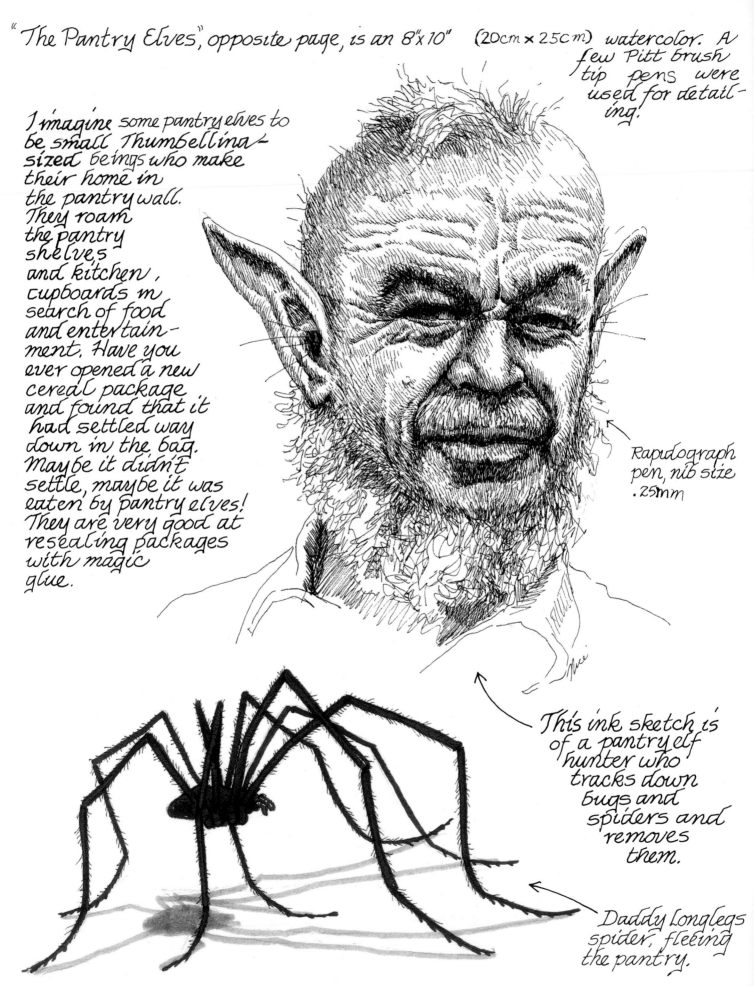

"The Pantry Elves", opposite page, is an 8"x 10" (20cm x 25cm) watercolor. A few Pitt brush tip pens were used for detailing.

I imagine some pantry elves to be small, Thumbellina-sized beings who make their home in the pantry wall. They roam the pantry shelves and kitchen, cupboards in search of food and entertainment. Have you ever opened a new cereal package and found that it had settled way down in the bag. Maybe it didn't settle, maybe it was eaten by pantry elves! They are very good at resealing packages with magic glue.

Rapidograph pen, nib size .25mm

This ink sketch is of a pantry elf hunter who tracks down bugs and spiders and removes them.

Daddy Longlegs spider, fleeing the pantry.

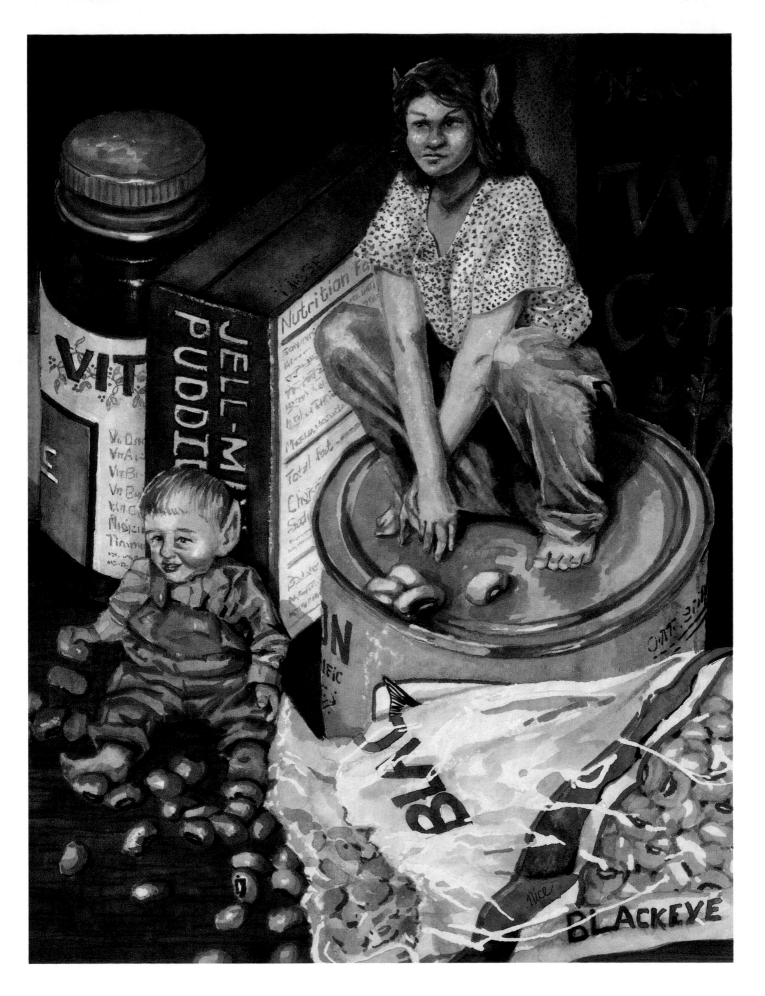

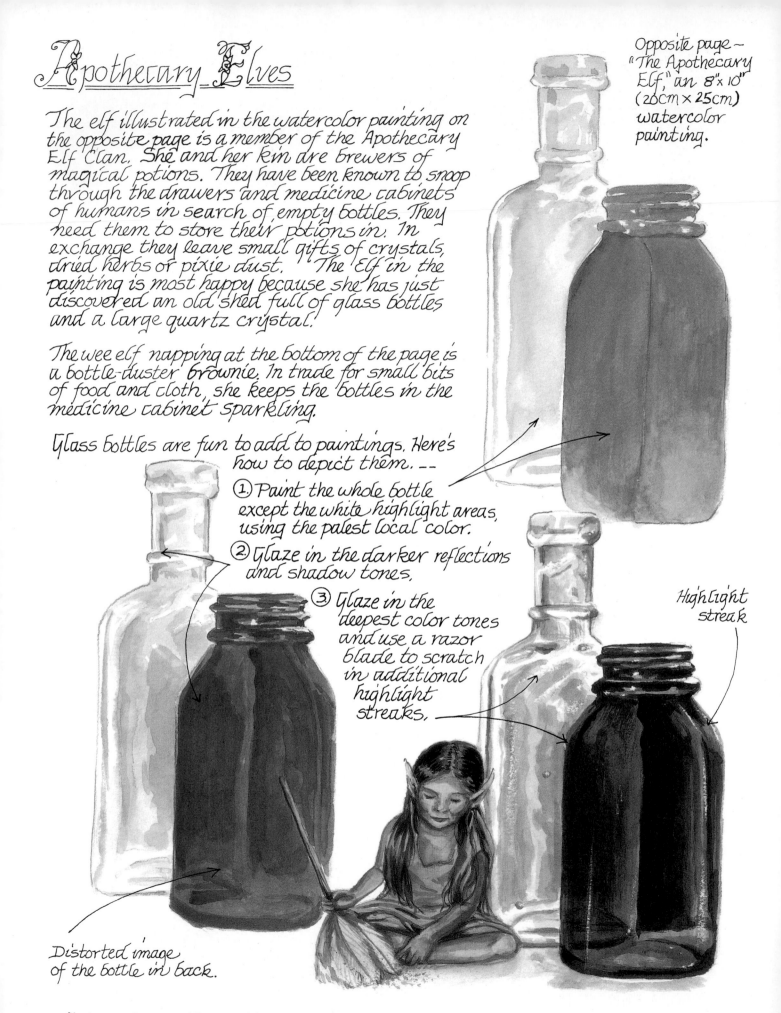

Apothecary Elves

The elf illustrated in the watercolor painting on the opposite page is a member of the Apothecary Elf Clan. She and her kin are brewers of magical potions. They have been known to snoop through the drawers and medicine cabinets of humans in search of empty bottles. They need them to store their potions in. In exchange they leave small gifts of crystals, dried herbs or pixie dust. The Elf in the painting is most happy because she has just discovered an old shed full of glass bottles and a large quartz crystal!

The wee elf napping at the bottom of the page is a bottle-duster brownie. In trade for small bits of food and cloth, she keeps the bottles in the medicine cabinet sparkling.

Glass bottles are fun to add to paintings. Here's how to depict them. --

① Paint the whole bottle except the white highlight areas, using the palest local color.

② Glaze in the darker reflections and shadow tones.

③ Glaze in the deepest color tones and use a razor blade to scratch in additional highlight streaks.

Opposite page ~ "The Apothecary Elf," an 8"x 10" (20cm x 25cm) watercolor painting.

Highlight streak

Distorted image of the bottle in back.

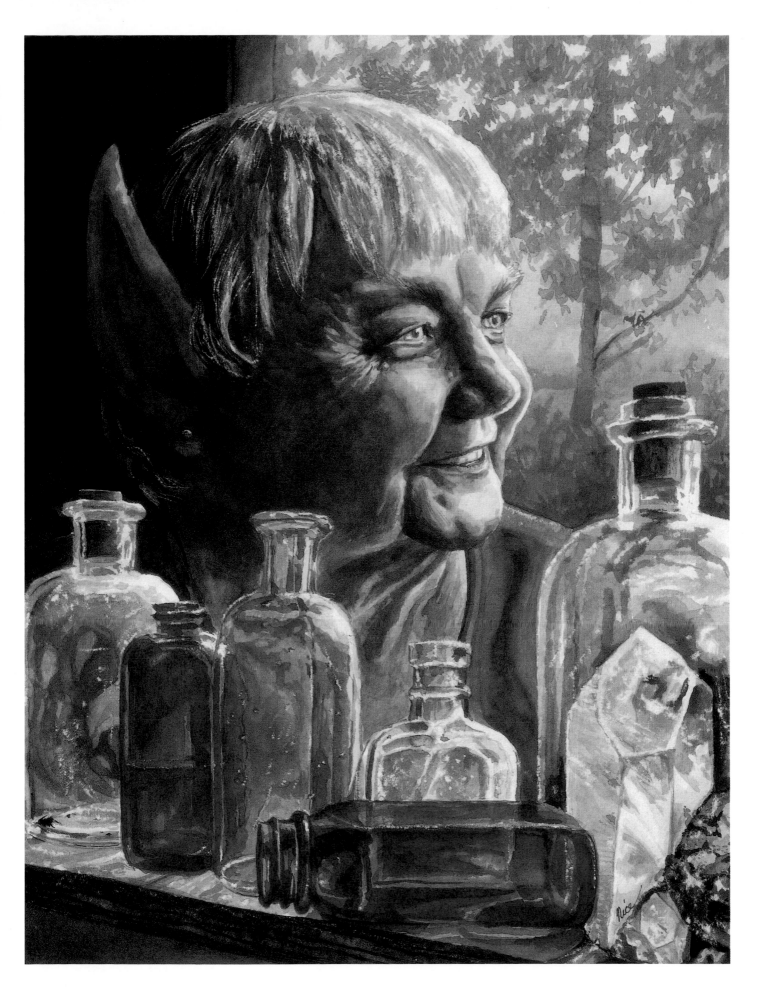

Workshop Elves

I see workshop elves as very talented in their craft, working with their human counterparts as partners. The most famous of these are the toymaker elves, that are said to work in Santa's workshop.

This master toy maker elf is hug testing a Teddy Bear he has just made.
.25mm and .50 mm Rapidograph pens were used on the drawing.

Opposite page—
"The Toy Maker Elves," is a 10" x 8" (25cm x 20cm) ink drawing, overlayed with watercolor wash.

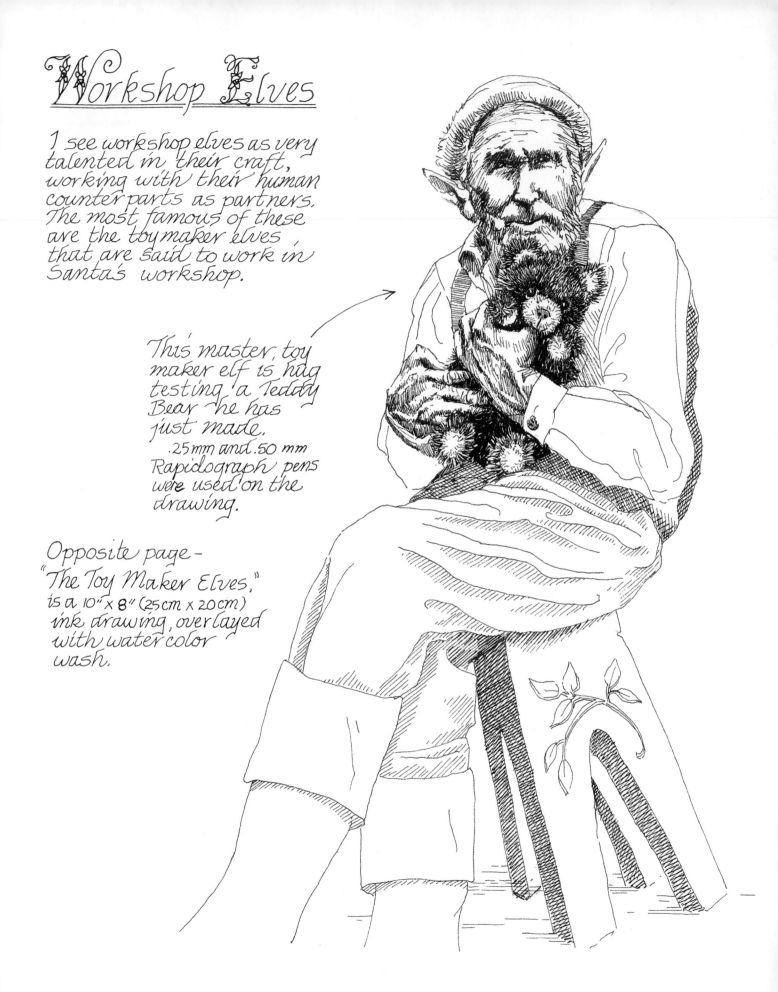

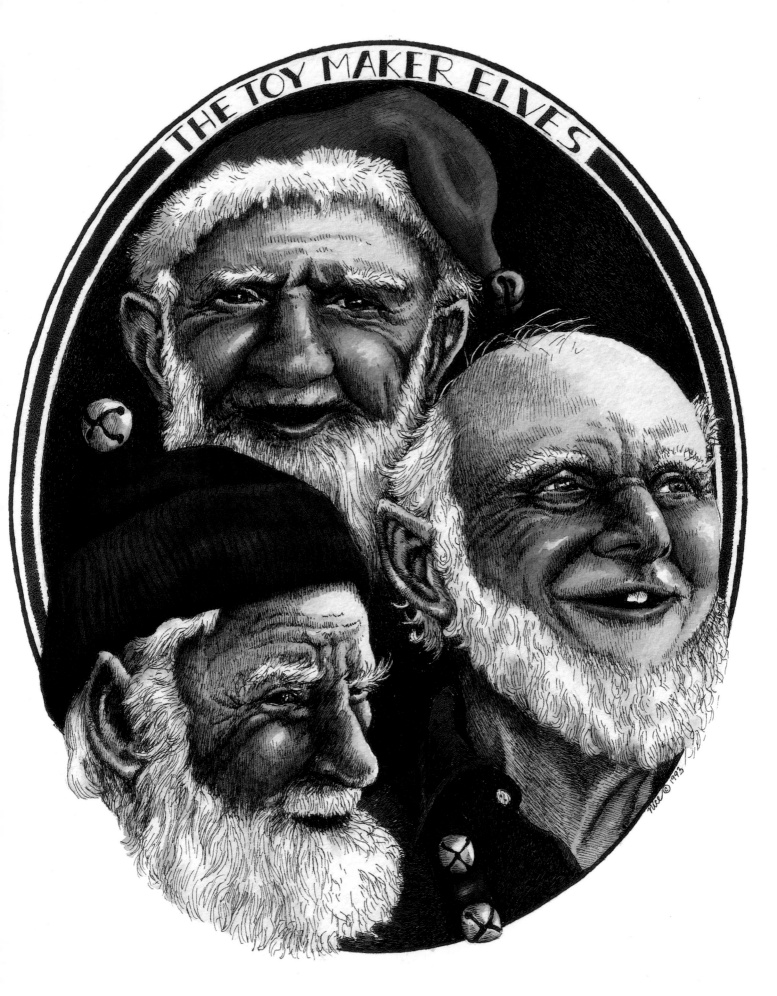

THE TOY MAKER ELVES

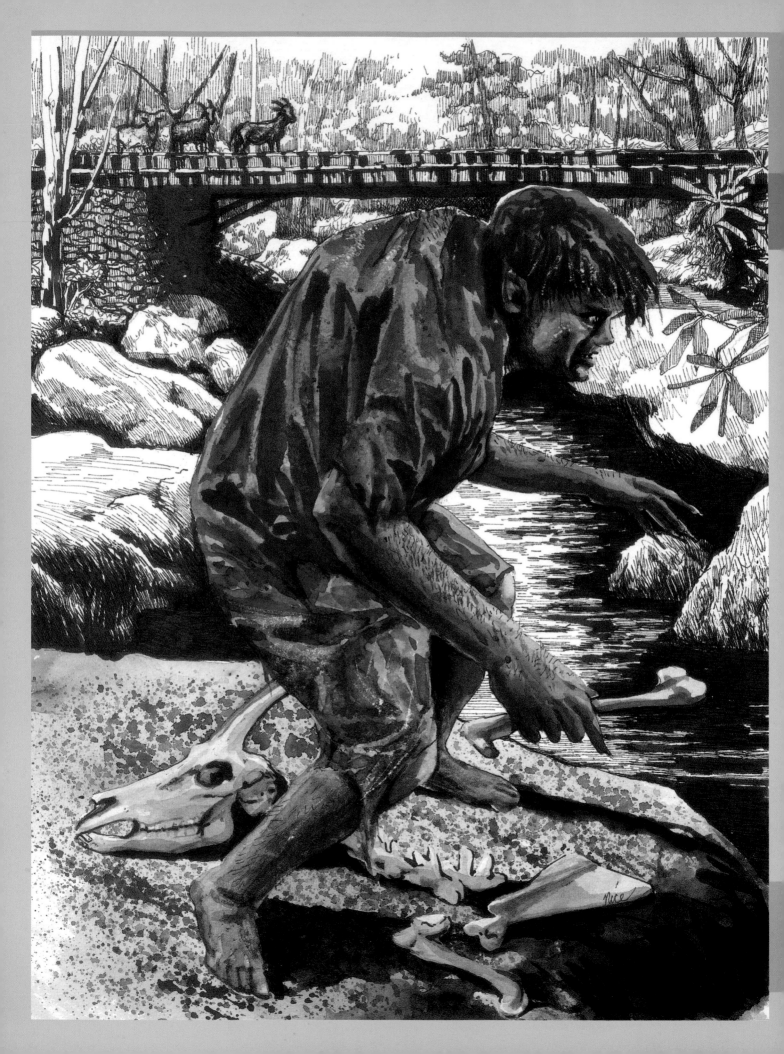

Gruff & Grisly Fay

rolls, gnomes, gremlins, and ogres are the black sheep of the fantasy kingdom. I became acquainted with them in the fairy tales that were read to me as a child. One of my favorites was the story of The Three Billy Goats Gruff and the mean troll who lived under the bridge. My mother always made scary faces and deepened her voice when she read the part of the troll. I had no trouble imagining what trolls must look like—and they were awful! I saw a short, stocky creature, dressed in dull, raggedy clothes. His grubby face was misshapen with a perpetual snarl. The eyes were mean and squinty and the teeth were yellow, crooked and sharp. The troll in the story ate goats, but I was sure he could also eat children if he could catch them. As a child, my vivid imagination kept me concerned at night about what might be hiding under my bed or in the closet. Now my imagination serves me well as an artist. The sepia ink and watercolor illustration on the opposite page is of the bridge troll. His rust-stained hair and hunched back are a result of many hours spent crouched in the girders beneath the bridge, waiting for the goats to come. The pencil portrait on this page illustrates another troll, smaller in stature, but just as mean. I had a lot of fun creating the villains in this chapter. The first few pages will show you how to draw a face with a nasty, troll-like attitude. Then we'll explore some ruins, caves and crevices to see who's home.

Bridge Troll
Pen, Ink and Watercolor
8" × 10" (20cm × 25cm)

Drawing Scowls and Growls

The facial features, especially the eyes and mouth, do interesting things when expressing anger. The best way to study these expressions is to photograph a friend or relative posing with a scowl. In the drawing shown below, I changed an angry-faced photo into a troll with an attitude.

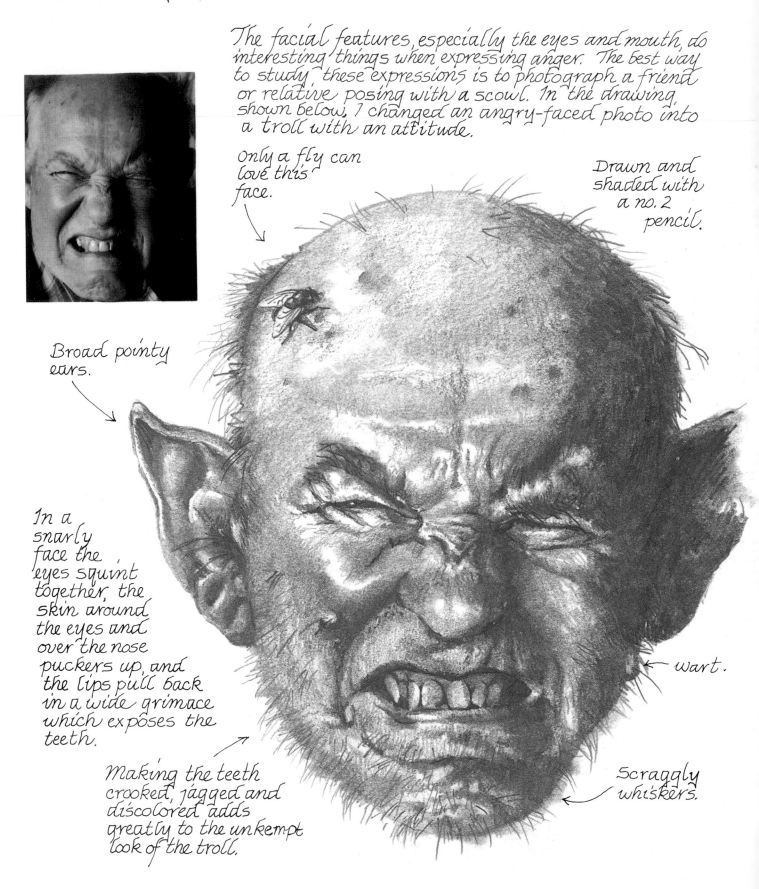

Only a fly can love this face.

Drawn and shaded with a no. 2 pencil.

Broad pointy ears.

In a snarly face the eyes squint together, the skin around the eyes and over the nose puckers up, and the lips pull back in a wide grimace which exposes the teeth.

Making the teeth crooked, jagged and discolored adds greatly to the unkempt look of the troll.

Wart.

Scraggly whiskers.

The mouth is the most flexible of the facial features and along with the eyes, it creates the expression and mood reflected on the countenance. Learning to draw an expressive mouth will help your characters come alive.

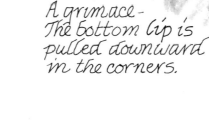

Teeth are only brought into strong focus when you want them to look bad.

A generic mouth turned slightly to the side. →

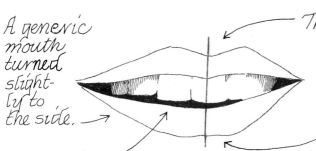

The upper lip dips down in the center, and the bottom lip rises slightly in the center along the bottom edge.

Merely suggest the outline of the teeth.

A toothless mouth has no dental arch to give it shape.

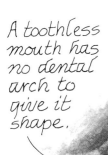

Squinty eyes. →

Soft, puckery lips.

A grimace - The bottom lip is pulled downward in the corners.

There is a furrow under the bottom lip. This is more pronounced in men.

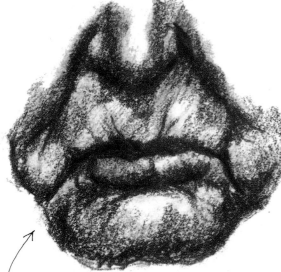

A stern mouth.

An ink sketch of a mouth rounded in surprise, or perhaps it's whistling. →

Trolls

The earliest stories of trolls came from Scandinavia. They were said to be a race of creatures who were somewhat human-like in appearance, but extra strong, extra ugly, unkempt and surly. They vary greatly in size. Some story-tellers conceive them as lumbering giants, while others describe them as dwarfed in size. They are solitary in nature, probably too mean to form lasting relation-ships, even with their own kind. Troll dens are found in dark, dank places like caverns, abandoned mine shafts, sewer tunnels, and cellars.

A troll in its den.

.25mm & .50 mm pen nibs were used.

Do trolls smile? Of course they do, just before they do something evil. It looks more smug-faced than happy. The eyes are open wide with expectation. The mouth stretches tightly across the face, slightly open, but does not turn up at the edges in a friendly gesture.

I have painted the portrait on this page in several steps so you can see how it progressed. It's of a female troll who is smiling because she sees a traveler heading up the path to her cave. The entrance is bewitched. If the traveler crosses its threshold, he will fall into a deep sleep and the old she-troll will empty his pockets and knapsack.

① The preliminary pencil sketch. Guide lines are erased before the brush-work starts.

A Black Widow spider's nest is part of her hairdo.

② The first water-color washes are laid down. The blue shadow tones will give a cold, un-healthy look to the skin. Perfect for a cave dweller!

③ A wash of pale pinkish brown adds life to the face. The sweater and wispy hair are a mixture of Payne's Gray and Sepia.

Trolls have been known to eat cock-roaches, but this one is a pet.

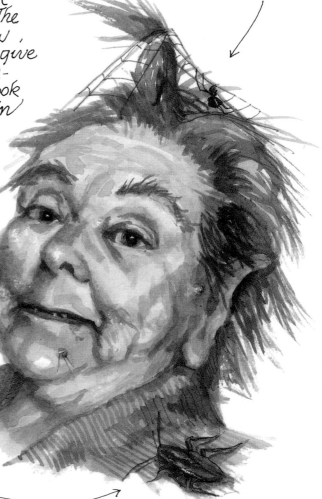

A nasty giant mountain troll has come out of his cavern to stalk the countryside. Perhaps he is looking for a bed sheet drying on a clothes line. That's where he got the material for the tattered shirt he has on now. It's more likely he is after a cow or pig to carry back to his cave.

A bit of background can add a lot to the story an illustration tells. The picket fence directly behind the giant troll gives the viewer an idea of just how big he really is.

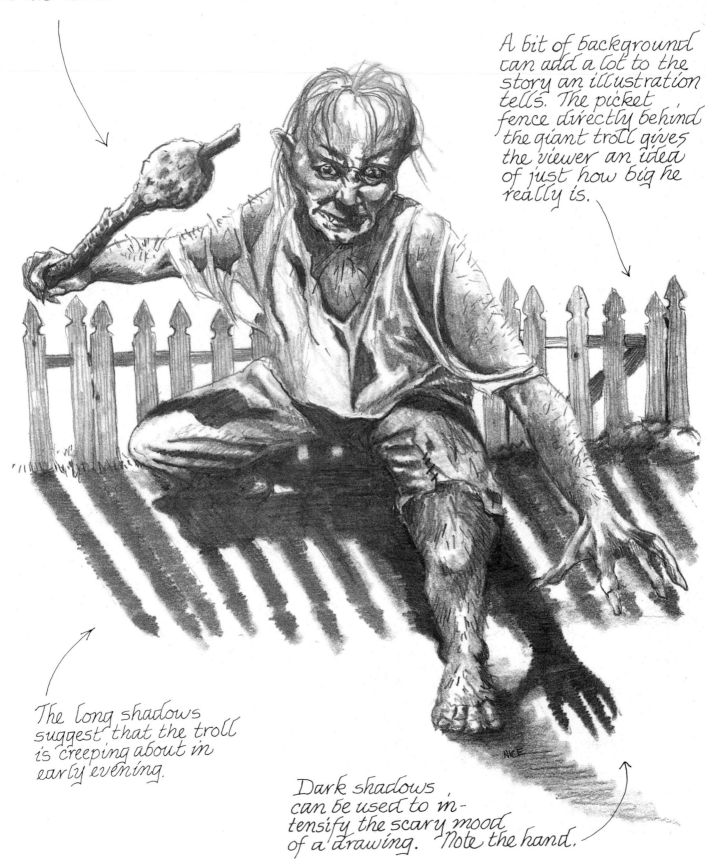

The long shadows suggest that the troll is creeping about in early evening.

Dark shadows can be used to intensify the scary mood of a drawing. Note the hand.

Drawing the Sinister Crouch

It seems that most trolls, ogres and movie monsters assume this stance when prowling about. In the crouched position the back is rounded, the legs spread apart, the knees deeply bent and the arms reaching **forward**.

In the front view of the crouch the arms and legs appear foreshortened.

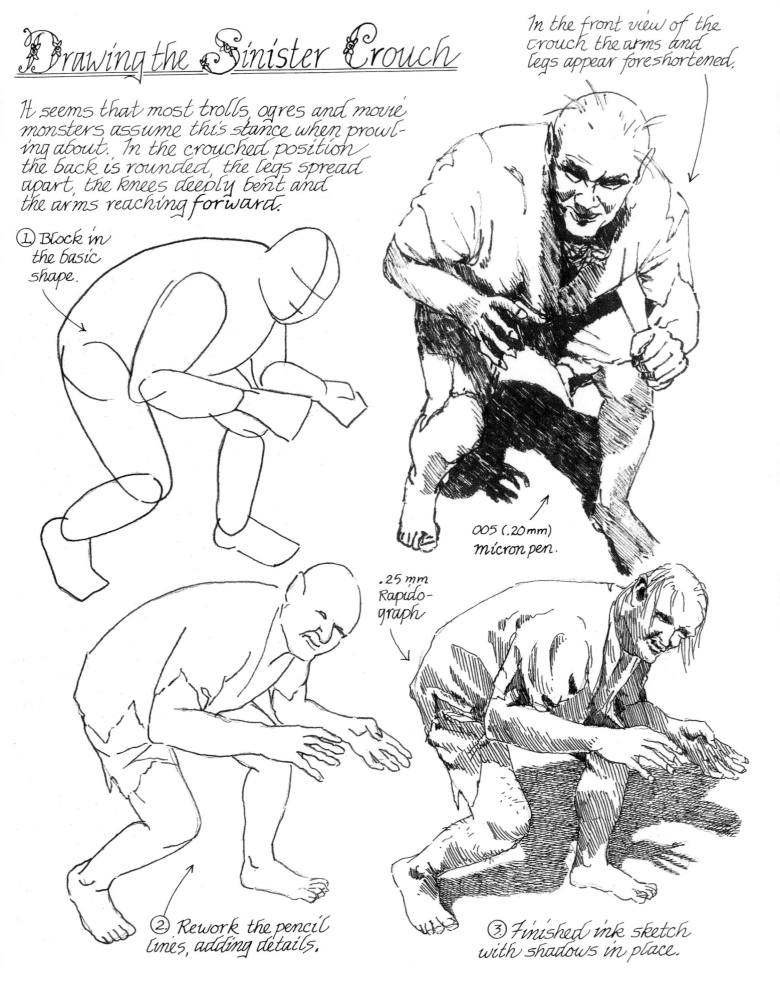

① Block in the basic shape.

005 (.20 mm) micron pen.

.25 mm Rapidograph

② Rework the pencil lines, adding details.

③ Finished ink sketch with shadows in place.

Creating Creepy Hands

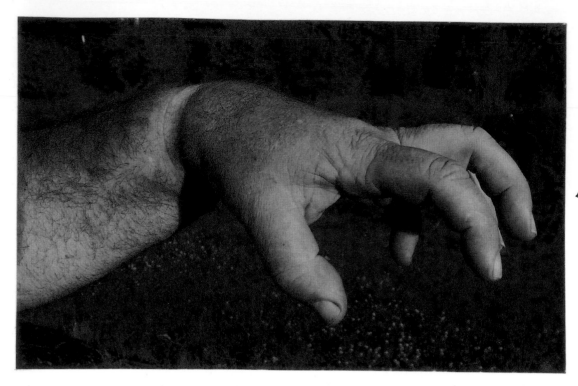

Pose the model hand in a clawing, grasping, gouging or otherwise threatening position.

A simple preliminary sketch. Pay attention to finger sections, knuckles and nails.

To draw a scary ogre, gremlin or troll you must know how to turn a human hand into something capable of wicked deeds. Here, are some changes to consider.

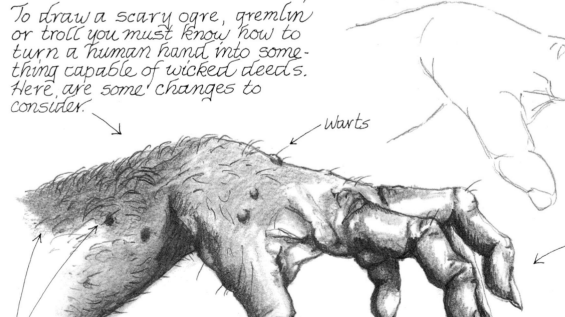

Warts

Once you have a convincing hand sketch, make the changes.

Hairs and age marks.

Bony fingers with enlarged knuckles.

Long, chipped, claw-like finger nails.

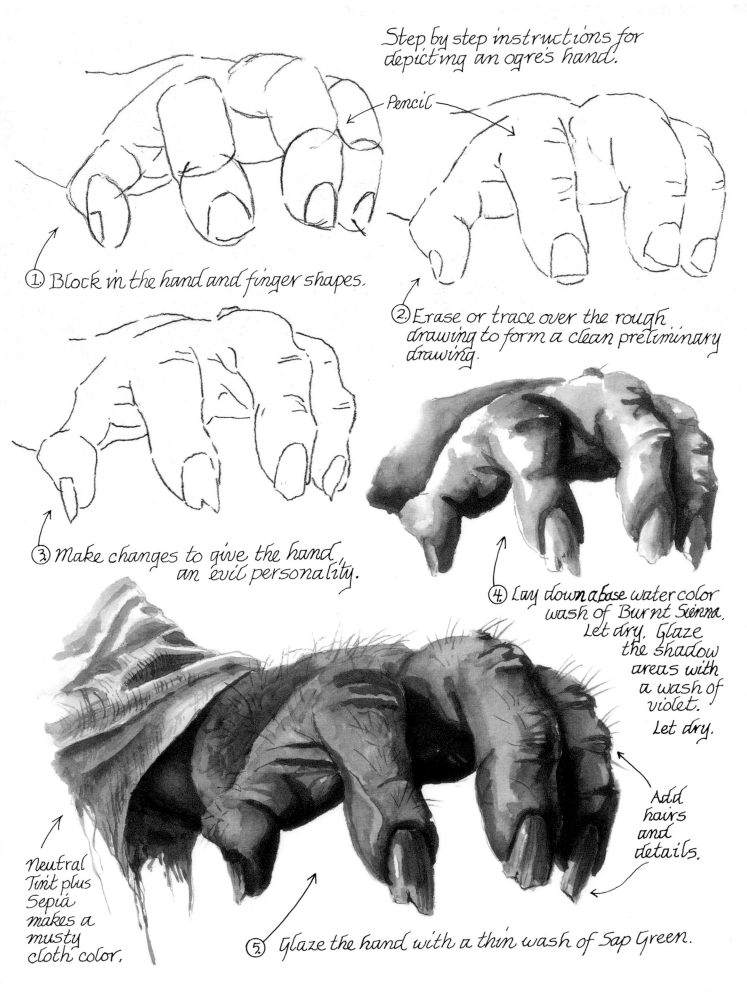

Step by step instructions for depicting an ogre's hand.

Pencil

① Block in the hand and finger shapes.

② Erase or trace over the rough drawing to form a clean preliminary drawing.

③ Make changes to give the hand an evil personality.

④ Lay down a base water color wash of Burnt Sienna. Let dry. Glaze the shadow areas with a wash of violet.

Let dry.

Add hairs and details.

Neutral Tint plus Sepia makes a musty cloth color.

⑤ Glaze the hand with a thin wash of Sap Green.

Ogres

Ogres are the giant monstrous oafs of fairy tale fame. They are hideous, having fought among themselves until they are scarred, broken and malformed. They are flesh eaters. Legend has it that they are not beyond adding humans to their diet.

The ogre below has caught a sewer rat for a snack. It is dwarfed in the giant's huge fist.

Due to their poor eating habits, ogres typically have thin hair, bad eye sight, and rashy, erupted skin.

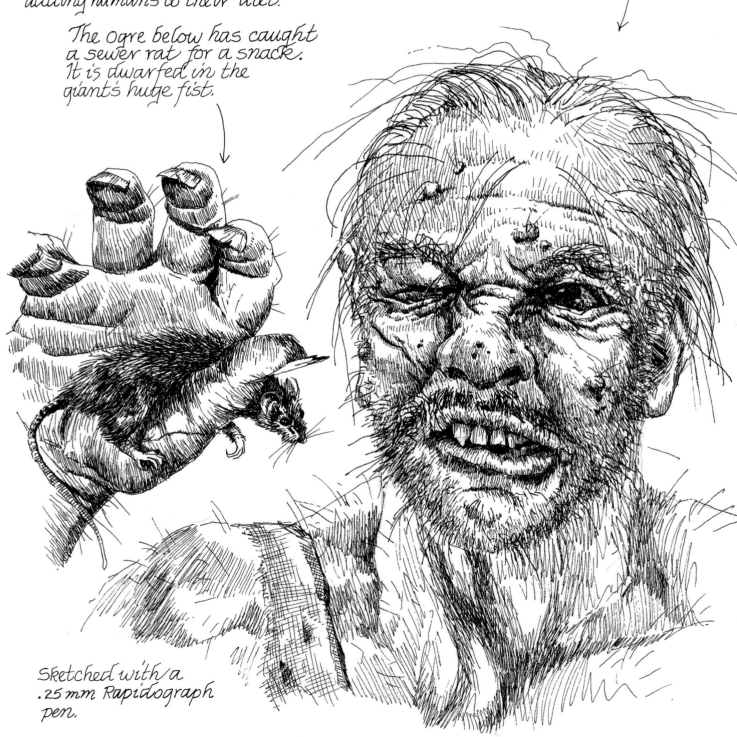

Sketched with a .25 mm Rapidograph pen.

This evilly gleeful ogre is called Drooletta, for obvious reasons. She has just discovered a pig caught in her pit trap.

This portrait was painted in watercolor with Pitt artist pen detailing.

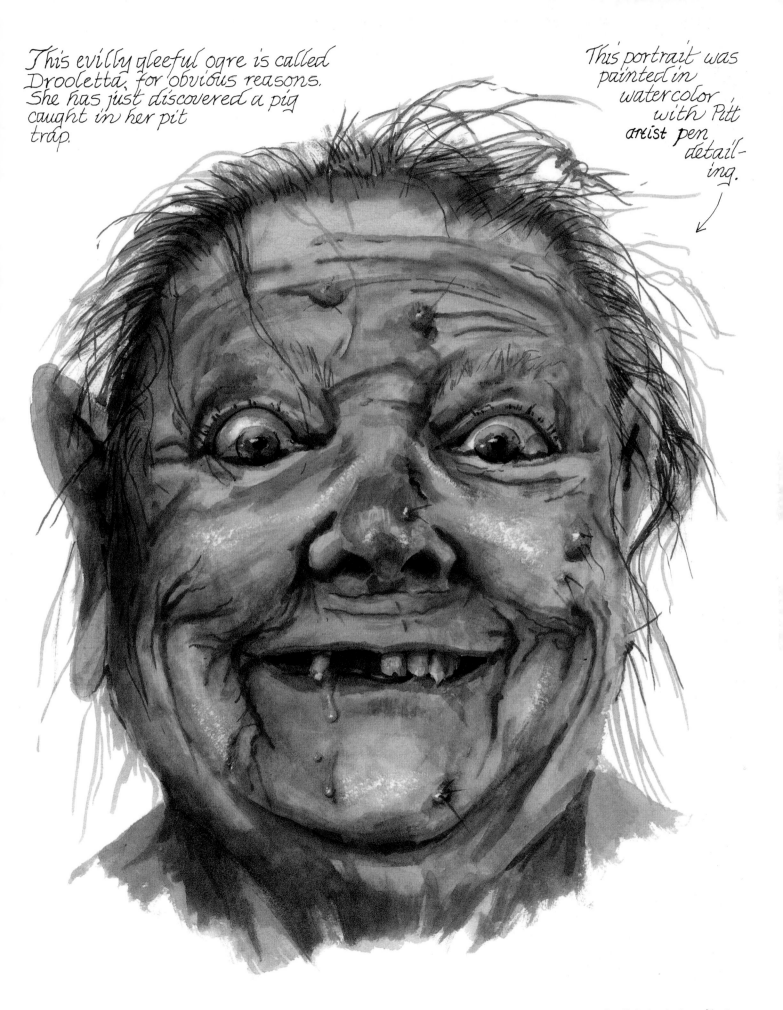

Dwarfs

The ledgendary dwarfs of times past were a race of short-statured, magical beings. They were gruff and secretive by nature, but not as nasty or as threatening as trolls and ogres. Female dwarfs are rarely mentioned in the old stories, but they must have existed. Dwarf men were described as heavily beard-ed creatures, who were stocky, often unkempt and sometimes mis-shapen. They were obsessed with gold, silver and precious gems. Many dwarfs were prospectors or miners who used magic spells to protect their claims.

The old dwarf, gold panner sketched here is showing off a huge gold nugget he discovered.

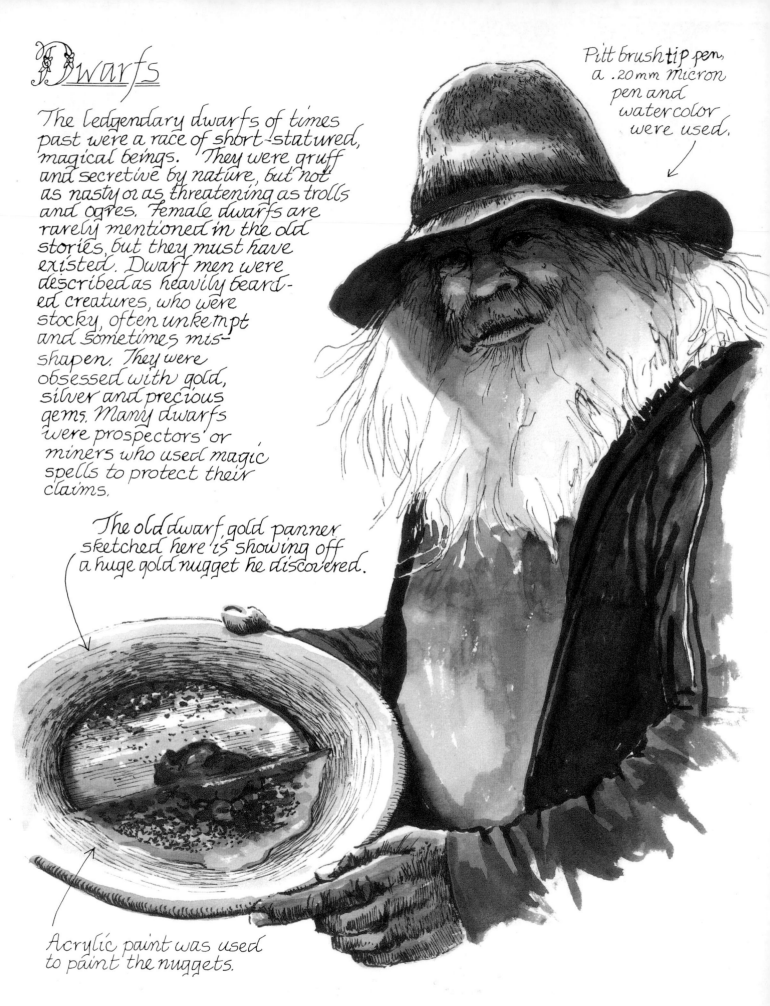

Pitt brush tip pen, a .20mm micron pen and watercolor were used.

Acrylic paint was used to paint the nuggets.

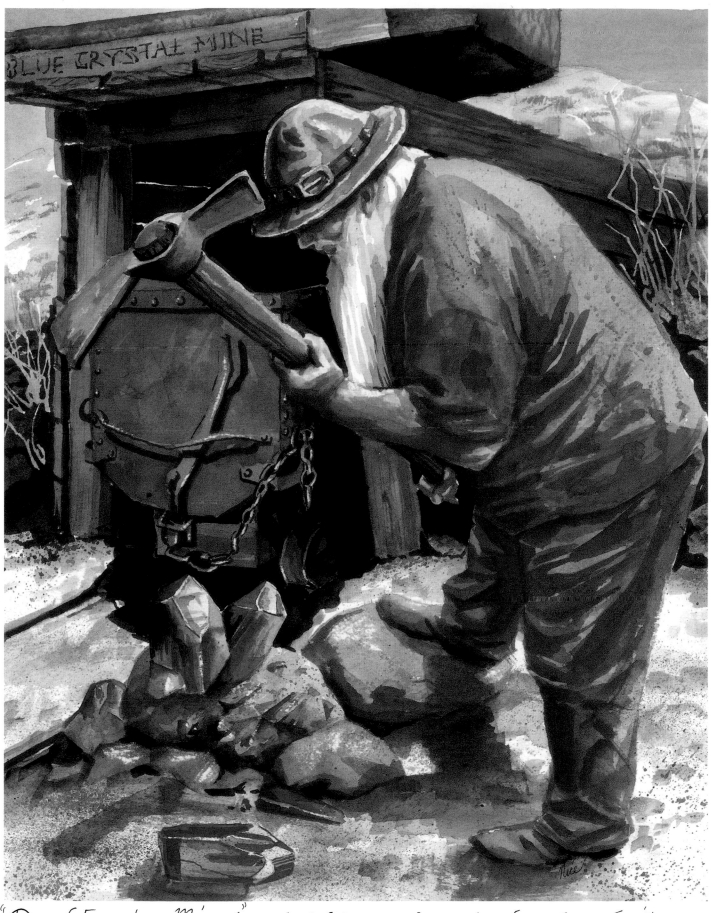

"Dwarf Gemstone Miner," an 8"x10" (20cm x 25cm) watercolor, enhanced with PITT brush pen detailing.

Interesting expressions, make the characters you are portraying come alive. The dwarf to the right wears an expression of deep concentration on his face. Perhaps he has spotted intruders on his claim.

Watercolor ———>

No. 2 writing pencil

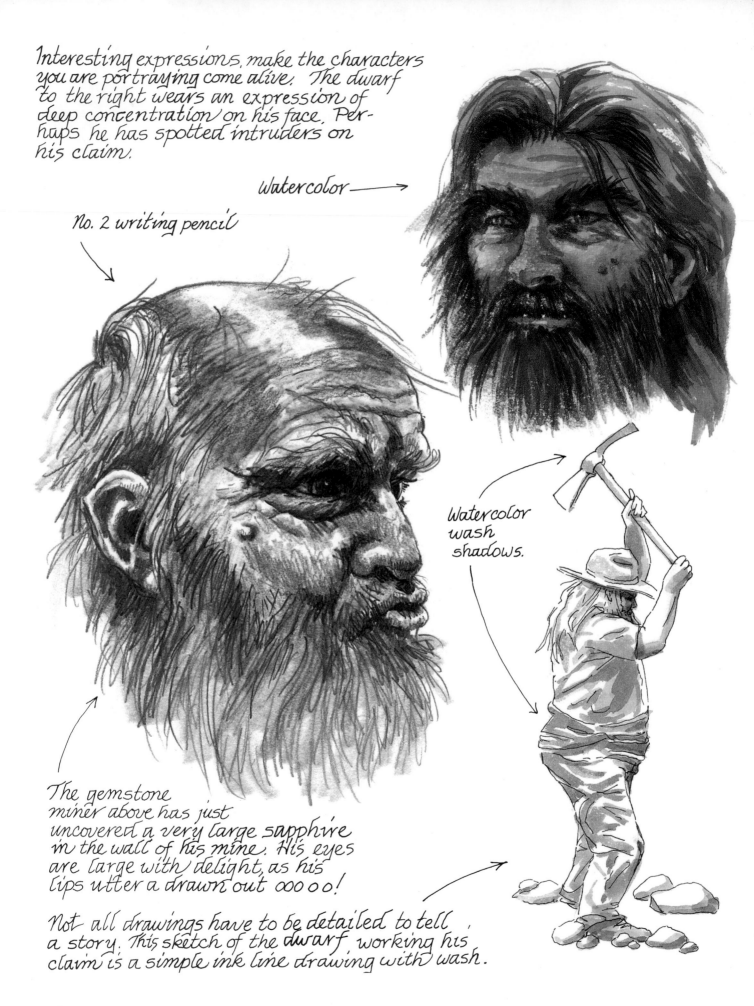

Watercolor wash shadows.

The gemstone miner above has just uncovered a very large sapphire in the wall of his mine. His eyes are large with delight, as his lips utter a drawn out ooooo!

Not all drawings have to be detailed to tell a story. This sketch of the dwarf working his claim is a simple ink line drawing with wash.

Gnomes

You may be familiar with garden Gnomes, those tiny, chubby, bearded creatures who patrol the flower beds looking for harmful pests. Their images, in the form of statues, are a common sight. However they have cousins who are not so nice! Cavern-dwelling Gnomes are dreadful, vicious beings whose life-work is guarding mines, treasures, etc. deep within the earth. In their protect-ive zeal they may cause mine cave-ins or other disasters.

Watercolor and Pitt brush **tip pen.**

Garden Gnome

Cavern Gnome →

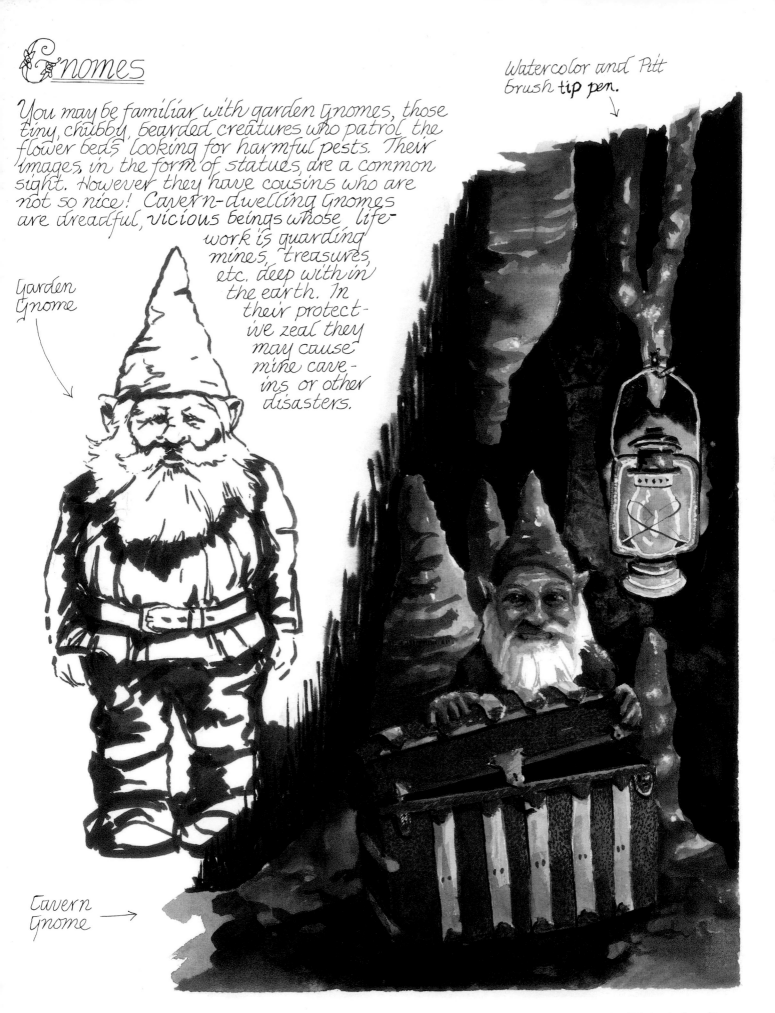

Goblins and Gremlins

These are grotesque little demons who delight in tormenting mankind with malicious pranks. They can be in the form of ugly, misshapen humans or take on animal qualities like the goat horns on the little green goblin illustrated below.

Gremlins have the ability to become invisible. Pilots in World War II believed that a pack of gremlins was responsible for many of the mechanical failures their planes had.

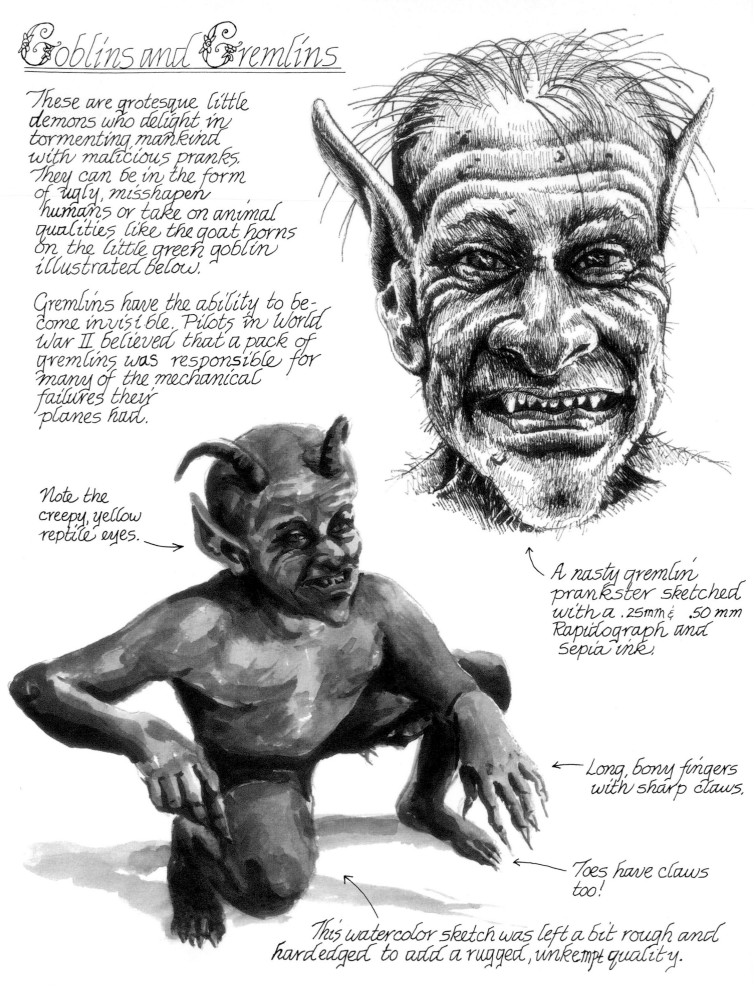

A nasty gremlin prankster sketched with a .25mm & .50 mm Rapidograph and sepia ink.

Note the creepy, yellow reptile eyes.

Long, bony fingers with sharp claws.

Toes have claws too!

This watercolor sketch was left a bit rough and hard edged to add a rugged, unkempt quality.

Create a Genie

According to myth, if you discover a magic lamp and rub it, you may set loose a genie. The genie in turn must grant you one or more wishes, but beware! Most genies are very crafty and hate greedy individuals. Should you wish to be worth more than any of your peers, you may find yourself turned into a gold statue. It may be safer to paint a genie than to conjure one up. Remember to give him a sly expression and a richly jeweled turban.

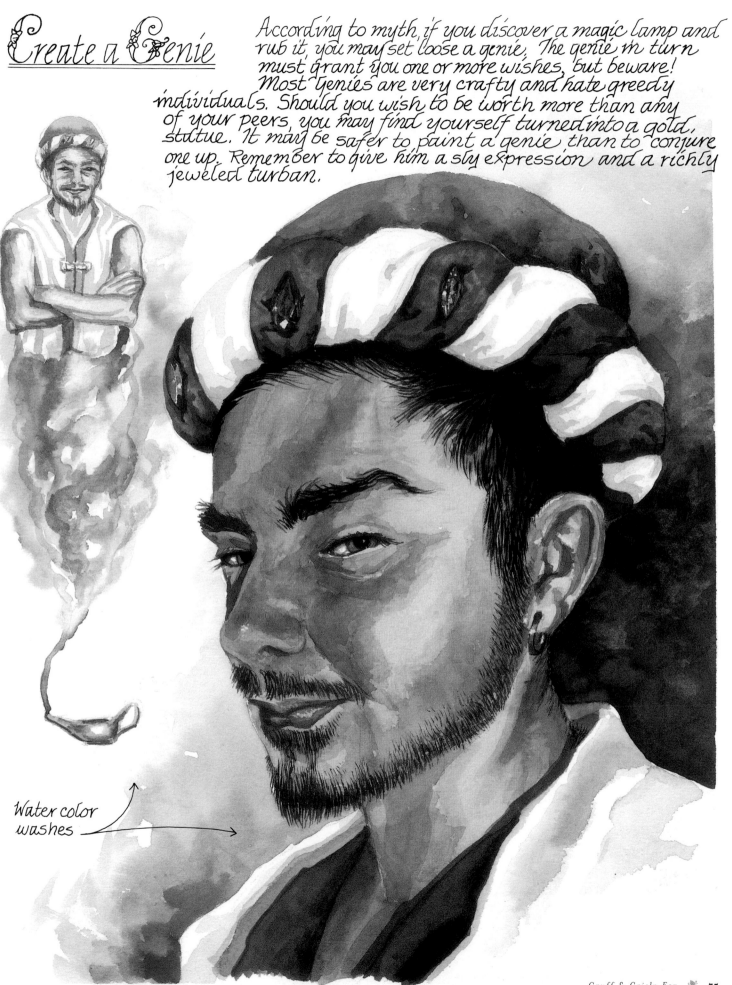

Water color washes

Sasquatch

Sasquatch or Bigfoot is the huge, ape-like creature that is rumored to inhabit the primeval forests of Western America. It's said that he smells terrible and his howl will chill your blood.

I asked my brother-in-law Steve to make a scary ape-like face. The resulting photo was the inspiration for the bigfoot pencil sketch seen below.

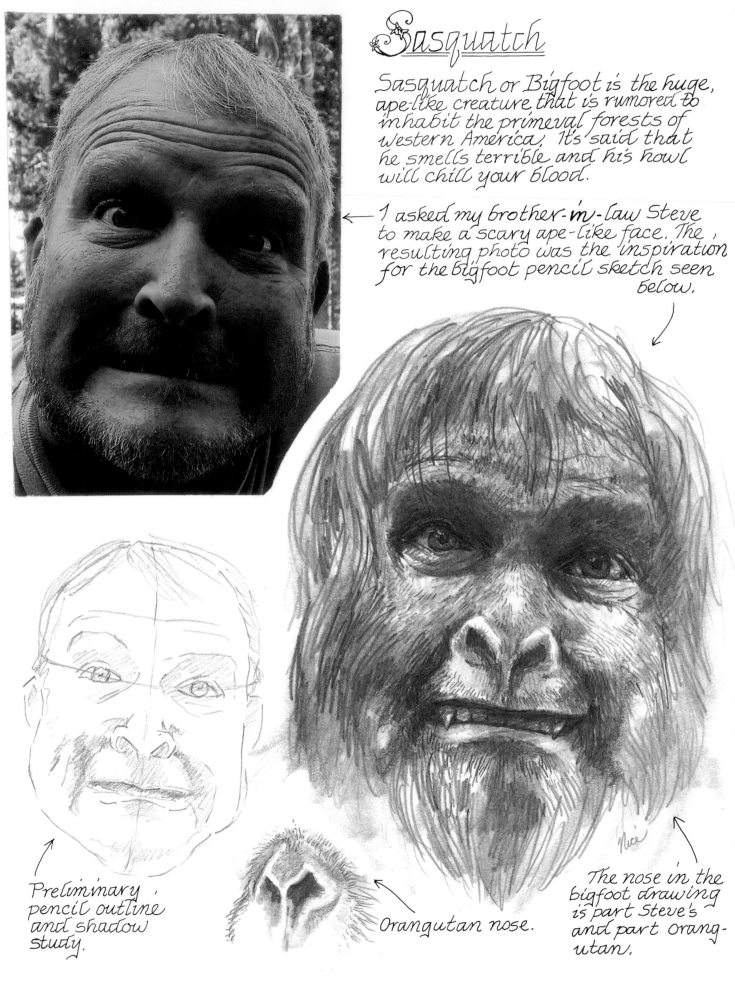

Preliminary pencil outline and shadow study.

Orangutan nose.

The nose in the bigfoot drawing is part Steve's and part orangutan.

The expressions on these faces will lend themselves well to becoming gruff and grumpy fantasy creatures.

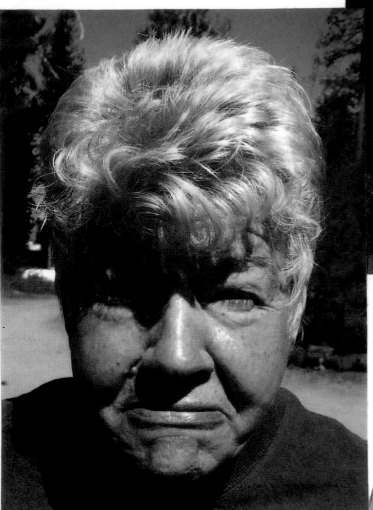

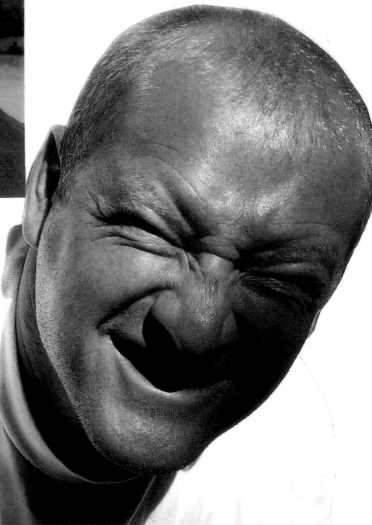

feel free to use the photos on this page to create your own version of trolls, gnomes, etc.

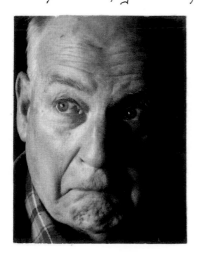

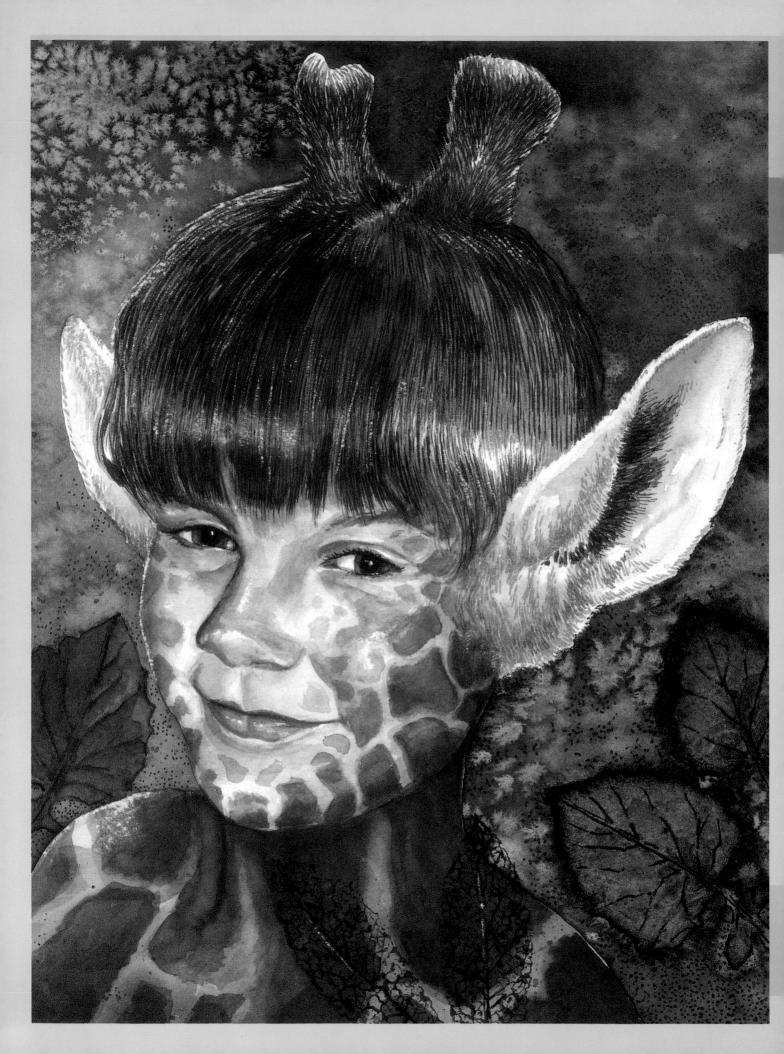

Chapter 4
Mythical Mixed Creatures

*I*n a dark era belonging to our ancient ancestors, sorcery overshadowed science, stories and ballads were more common than books, and eyesight was often poor (eyeglasses had yet to be invented). The result was the invention of extraordinary creatures that were deemed responsible for that which could not be explained or seen clearly. In the stories told from one hearth fire to the next, the creatures became established as myths, to be passed down from one generation to the next. Many of these mythical creatures consisted of mixed animal parts such as unicorns, griffins and Pegasus. Other creatures such as merpeople, centaurs, minotaurs, fauns and satyrs were part human. Some were even elevated to the status of deity.

These mythical mixed creatures are still popular and have been conjured up again and again in literature, movies and art. It's fun to draw the legendary creatures or makeup a few of your own. All you need are a few good photos or models to work from and enough imagination to fit them together.

This chapter is intended to inspire you and give you a boost with some animal drawing instructions. Let's begin with the portrait of a Giraffe Faun, painted in watercolor (opposite page). The inspiration was the photo I took of my neighbors' son Erik. The fun-loving gleam in his eyes begged me to turn him into either an elf or a mischievous forest faun. The faun won. Fauns usually have human bodies with goat horns, ears and legs. However, having just returned from the zoo with wonderful giraffe photos and sketches, I decided to add giraffe features to Erik's portrait. A dark green background with a sprinkling of salt texturing and leaf prints added just the woodsy background I needed to finish the project.

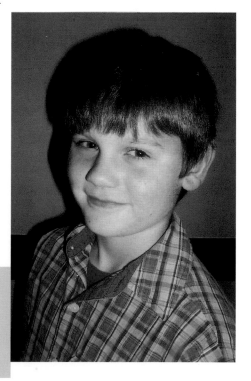

Giraffe Faun
Watercolor
8" × 10" (20cm × 25cm)

Drawing the Horse

There are many mythological creatures that have horse bodies. No matter how you envision Pegasus, unicorns and centaurs, knowing how to draw a basic horse form will be helpful in depicting them.

The model for this page is my appaloosa mare Lady Ta Wi.

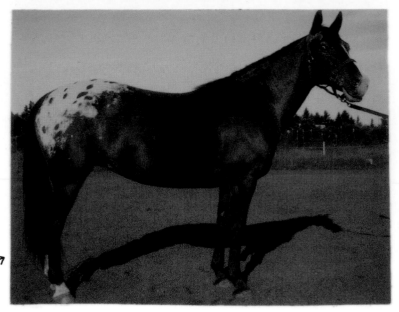

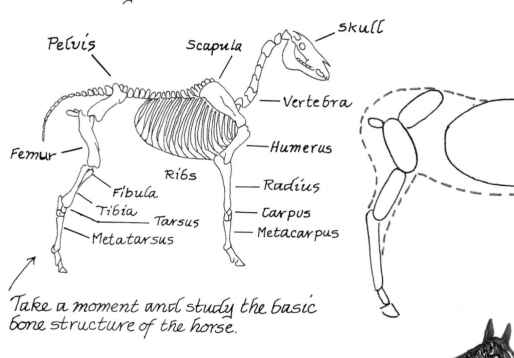

Pelvis

Scapula

skull

— Vertebra

Femur

— Humerus

Ribs

Fibula

Tibia

— Radius

Tarsus

— Carpus

Metatarsus

— Metacarpus

Take a moment and study the basic bone structure of the horse.

Turning the bones into simple shapes and laying them down like building blocks can help you draw a better horse.

This sketch was made in pencil and finished with a fine-nibbed sepia marker.

Having an idea where the bones and muscles are will be a big help when its time to shade in the contours of the animal.

Unicorns

The unicorn is basicly an elegant horse which bears a horn in the middle of it's forehead.

Here are some shapes from which to draw unicorn horns.

An Auger sea shell

A steinbok or antelope horn.

A candle taper.

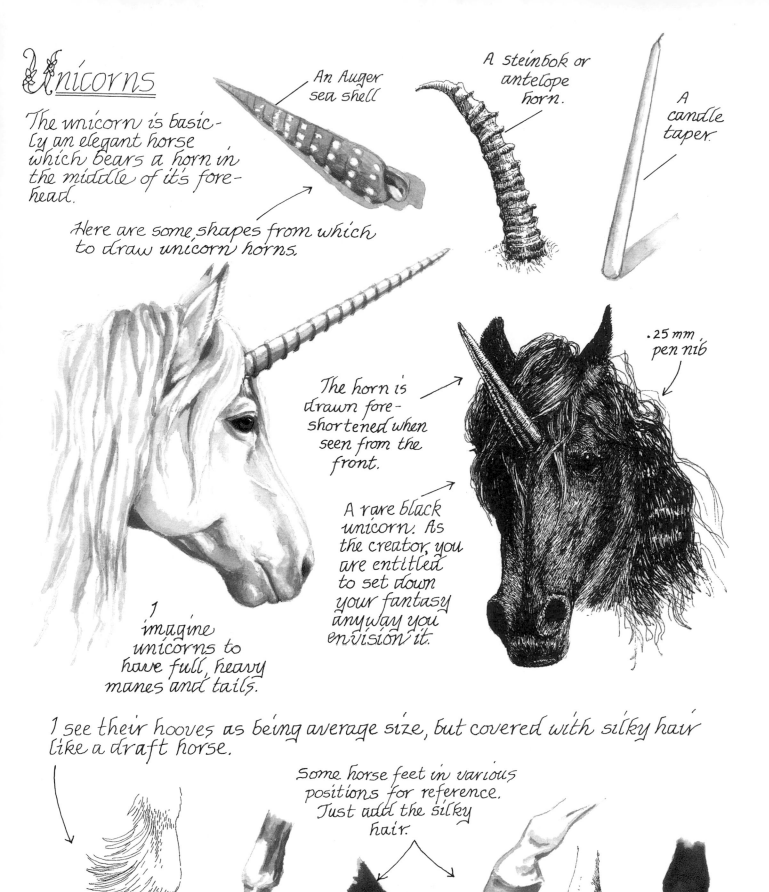

The horn is drawn fore-shortened when seen from the front.

A rare black unicorn. As the creator, you are entitled to set down your fantasy anyway you envision it.

.25 mm pen nib

I imagine unicorns to have full, heavy manes and tails.

I see their hooves as being average size, but covered with silky hair like a draft horse.

Some horse feet in various positions for reference. Just add the silky hair.

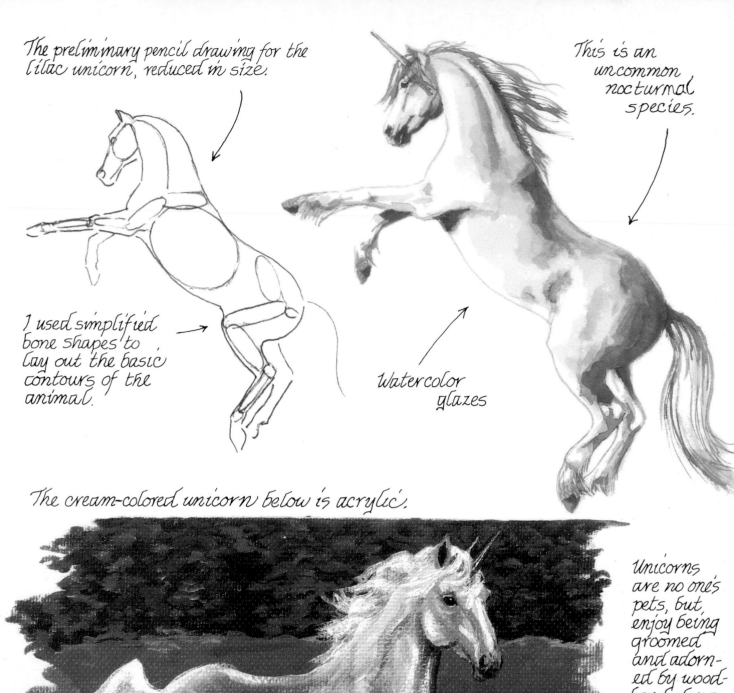

The preliminary pencil drawing for the lilac unicorn, reduced in size.

This is an uncommon nocturnal species.

I used simplified bone shapes to lay out the basic contours of the animal.

Watercolor glazes

The cream-colored unicorn below is acrylic.

Unicorns are no one's pets, but enjoy being groomed and adorned by woodland elves, in exchange for protection from trolls.

The unicorn on the opposite page wears birds foot violets woven in his mane.

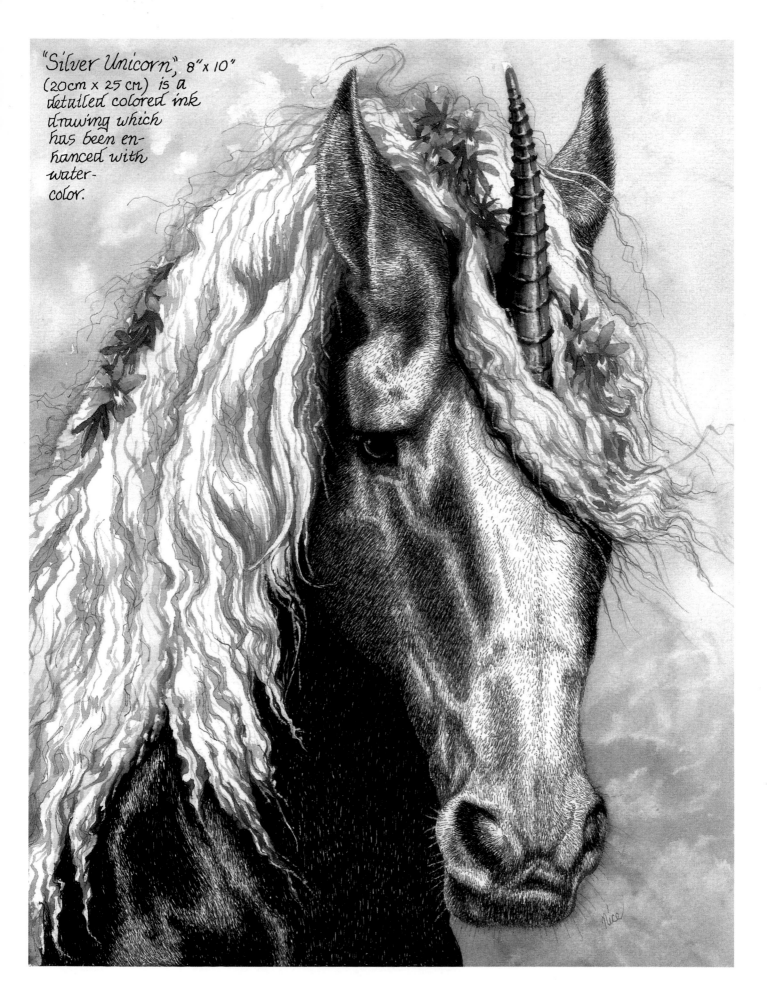

"Silver Unicorn", 8" x 10" (20cm x 25cm) is a detailed colored ink drawing which has been enhanced with watercolor.

The Centaur

This is a mythological creature with the body of a man from the waist up and the body of a horse from the waist down. Getting the two to join together in a convincing manner is the tricky part. As you hunt for likely sketching models, keep these suggestions in mind....

1. The torso of the man should be large enough to fit nicely into the chest area of the horse.

2. Centaurs were not wimps. Choose a powerful, stocky type for your horse model and give the man portion of your centaur some muscle. Muscle building magazines can be a good source of practice sketching poses, as long as you respect that the material is copyrighted.

3. Pay attention to light direction on the creatures you are combining. To make it convincing, the sun must hit the entire being from the same side and roughly from the same angle.

4. Match the action of both the horse body and the man torso. It would appear quite strange to have the horse legs galloping and the man arms folded in repose.

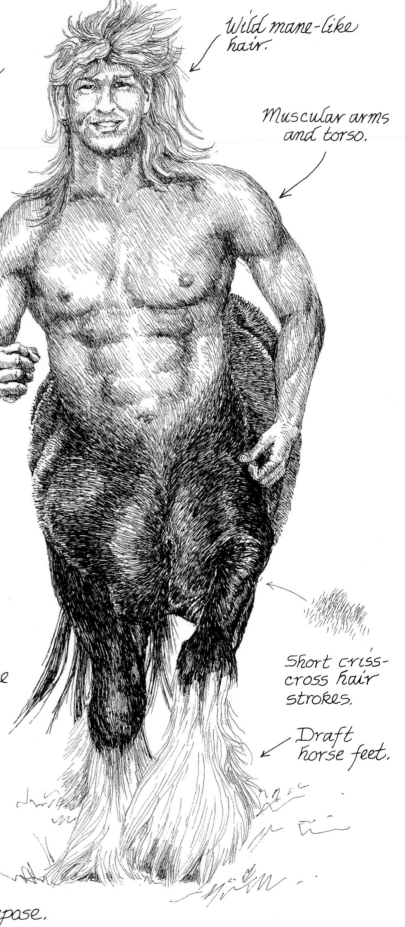

Wild mane-like hair.

Muscular arms and torso.

Short criss-cross hair strokes.

Draft horse feet.

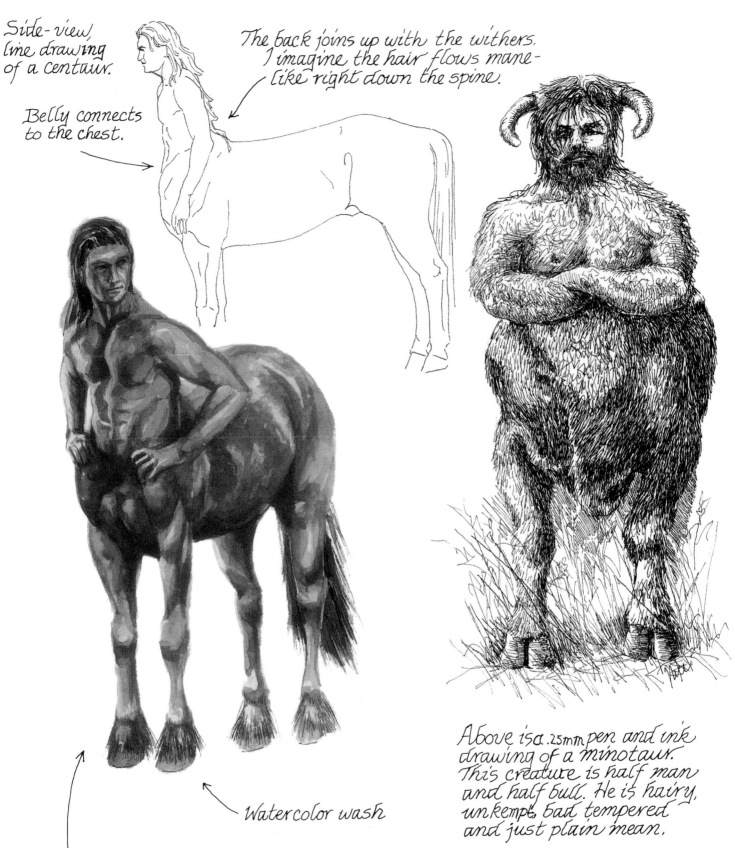

Side-view, line drawing of a centaur.

The back joins up with the withers. I imagine the hair flows mane-like right down the spine.

Belly connects to the chest.

Watercolor wash

The base color of this centaur is Burnt Sienna. I added warm yellow for the golden hues and green or sepia for the shadow tones.

Above is a .25mm pen and ink drawing of a minotaur. This creature is half man and half bull. He is hairy, unkempt, bad tempered and just plain mean.

I used a loose, scribble stroke to complete the sketch, which added to the minotaur's wild and wooly appearance.

Mythical Mixed Creatures 🍃 85

Drawing Birds

Birds, especially their wings, are often a part of combination fantasy creatures.

Note that inside the wing are the same bones that would form the hand, wrist, and arm of a human.

To imitate the motion of a bird's wing, place your elbow against your side, with your forearm brought up, and foreward. Bend your wrist down slightly. Now wave your arm forward and back in a circular motion. If you were a bird you would be flying.

Anatomy of a songbird.

(hand)
radius
(elbow)
humerus
(wrist)
ribs
femur
pelvis
vertebrae
wishbone
sternum
knee
tibia
(heel)
tarso
(toes)

There are two basic shapes that can be used to draw the body of a bird, an oval and an egg.

The main differences between the various bird species are the length of the neck and legs, and the shape of the bill and feet. Compare the birds below.

A pelican painted in watercolor.

A bald eagle sketched using pencil, sepia ink and watercolor.

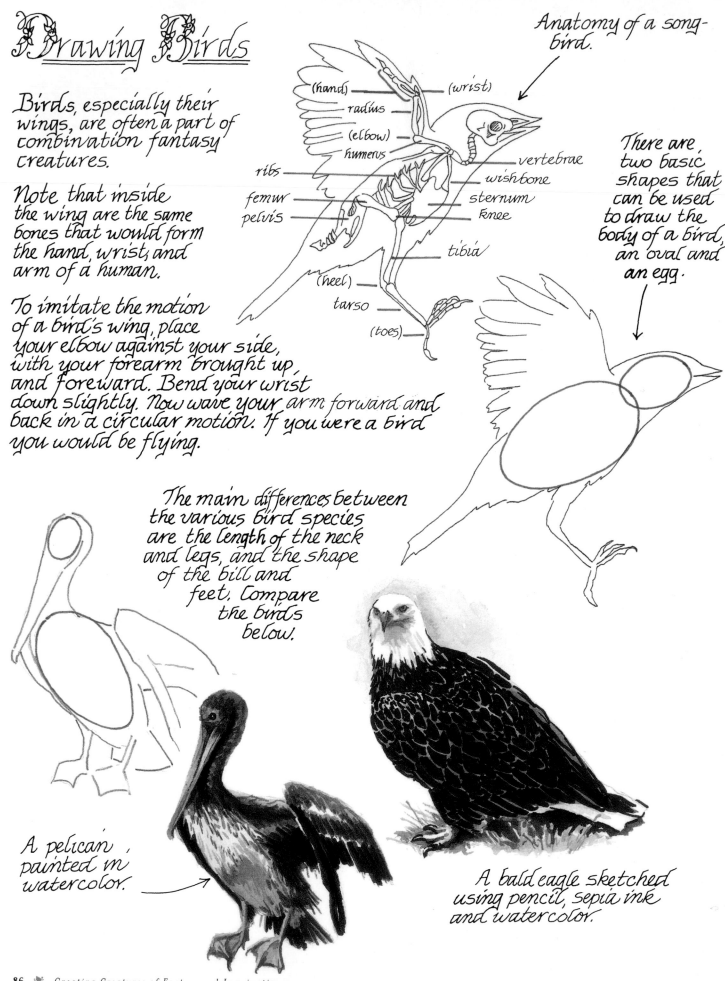

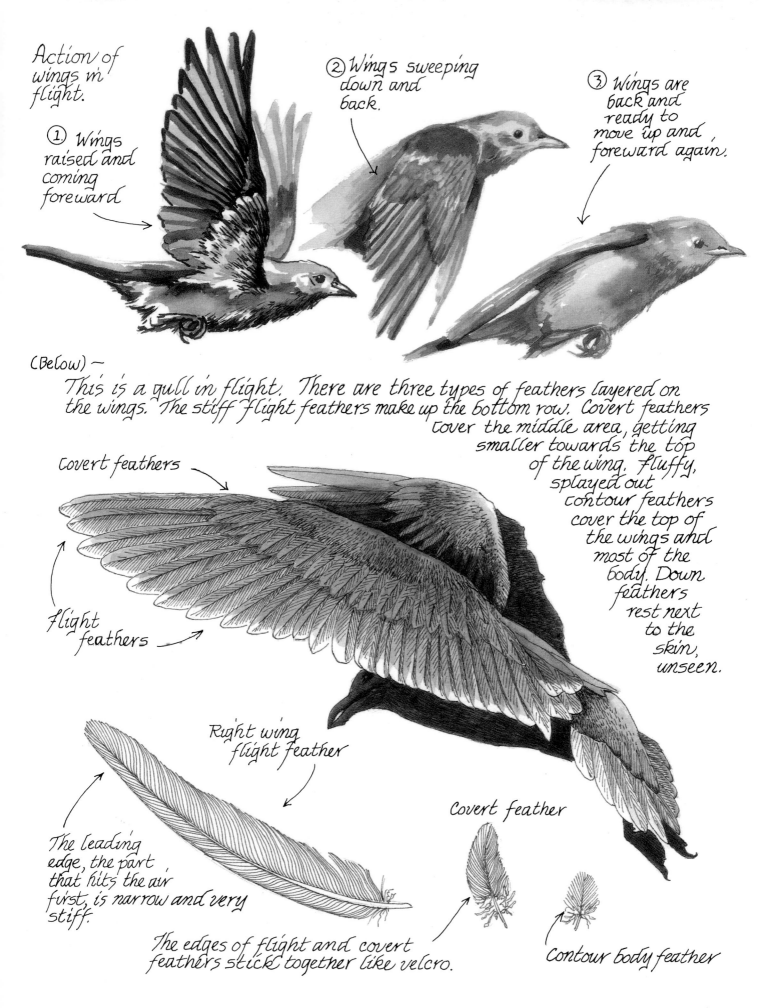

Action of wings in flight.

① Wings raised and coming foreward

② Wings sweeping down and back.

③ Wings are back and ready to move up and foreward again.

(Below) —

This is a gull in flight. There are three types of feathers layered on the wings. The stiff flight feathers make up the bottom row. Covert feathers cover the middle area, getting smaller towards the top of the wing. Fluffy, splayed out contour feathers cover the top of the wings and most of the body. Down feathers rest next to the skin, unseen.

Covert feathers

Flight feathers

Right wing flight feather

Covert feather

Contour body feather

The leading edge, the part that hits the air first, is narrow and very stiff.

The edges of flight and covert feathers stick together like velcro.

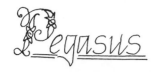

Pegasus

Combine an elegant white or light gray horse with a pair of wings from a large bird and you have Pegasus, a mythological creature.

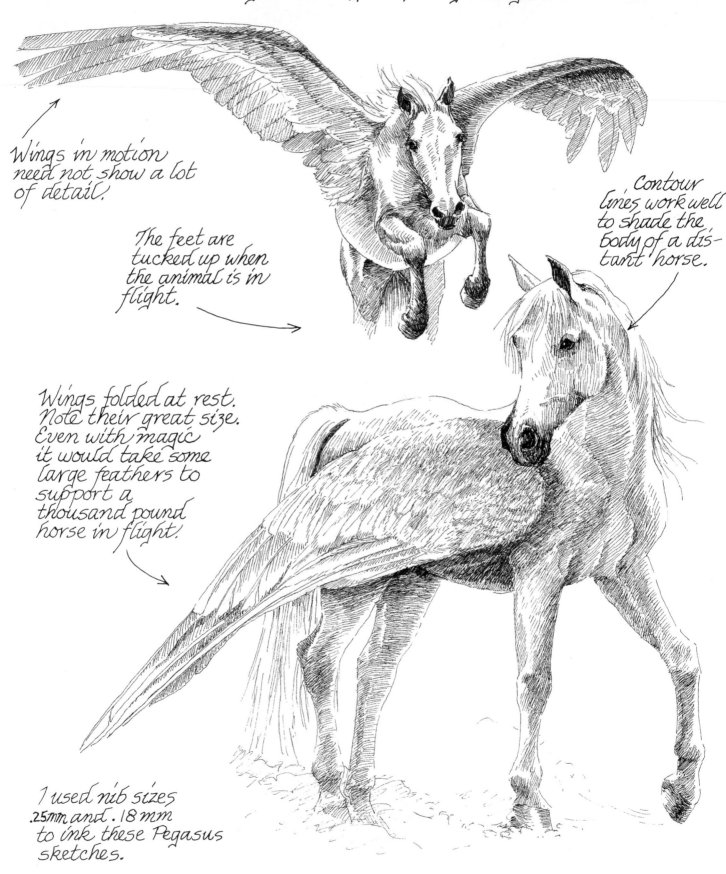

Wings in motion need not show a lot of detail.

The feet are tucked up when the animal is in flight.

Contour lines work well to shade the body of a distant horse.

Wings folded at rest. Note their great size. Even with magic it would take some large feathers to support a thousand pound horse in flight!

I used nib sizes .25mm and .18mm to ink these Pegasus sketches.

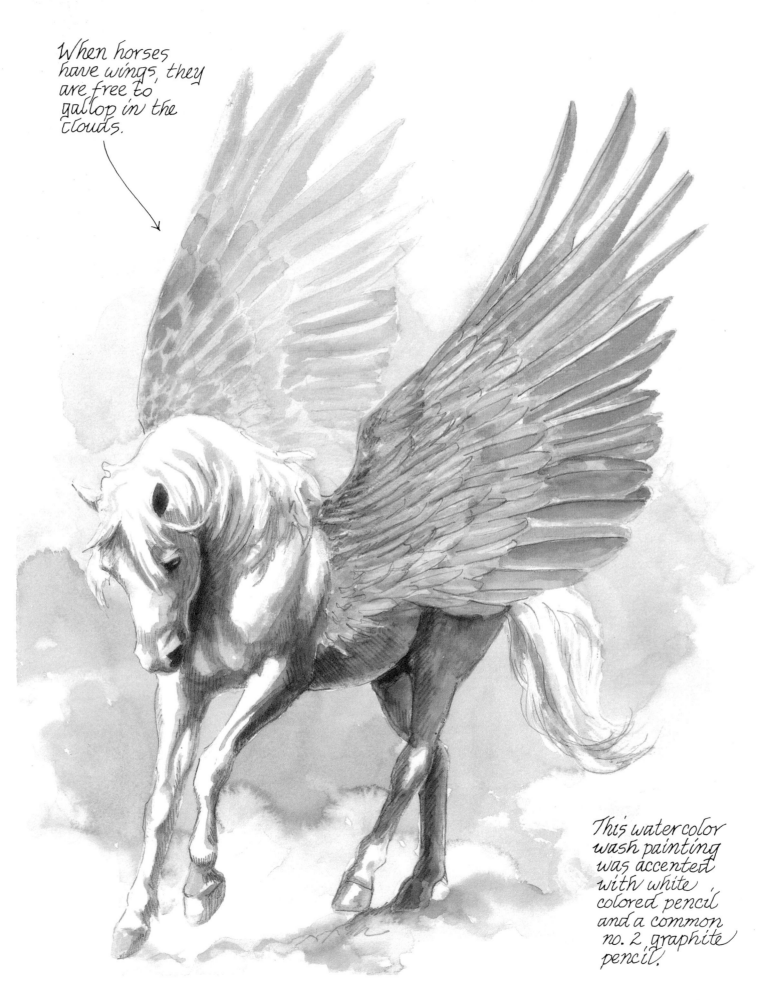

When horses have wings, they are free to gallop in the clouds.

This water color wash painting was accented with white colored pencil and a common no. 2 graphite pencil.

Lions

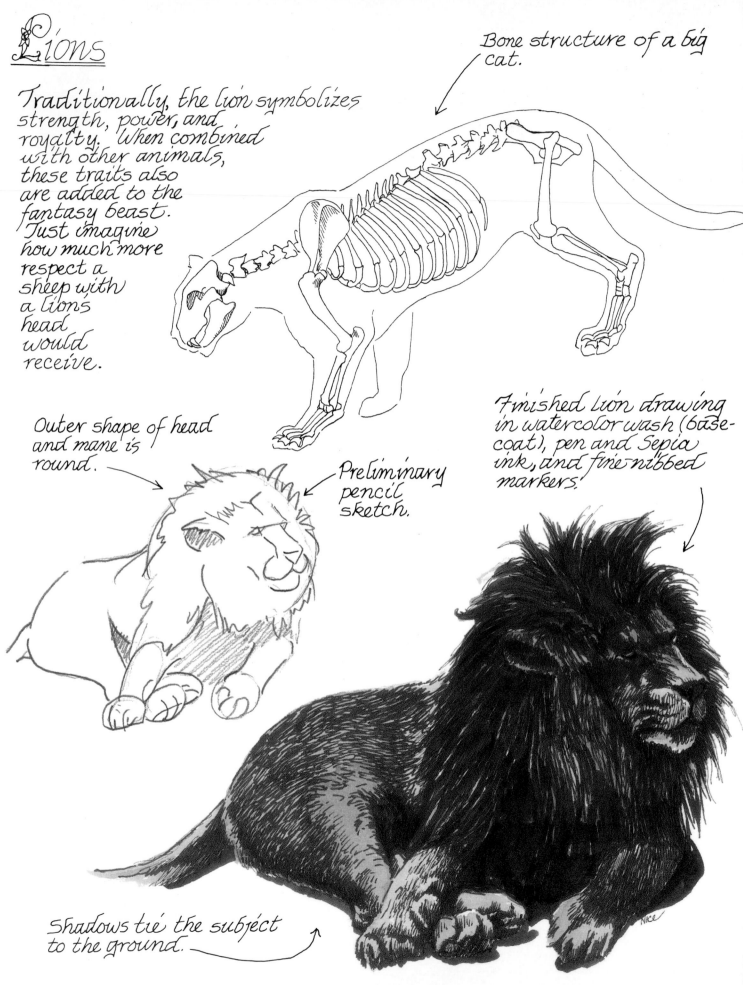

Traditionally, the lion symbolizes strength, power, and royalty. When combined with other animals, these traits also are added to the fantasy beast. Just imagine how much more respect a sheep with a lion's head would receive.

Bone structure of a big cat.

Outer shape of head and mane is round.

Preliminary pencil sketch.

Finished lion drawing in watercolor wash (base-coat), pen and sepia ink, and fine-nibbed markers.

Shadows tie the subject to the ground.

Nice

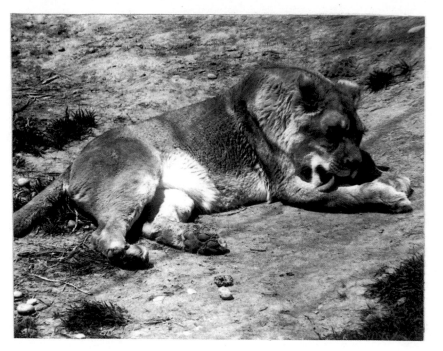

Looking for geometric shapes within the form of the animal I'm drawing helps me do away with preconceived ideas and really see the actual contours.

Here are the shapes I saw within the lion in the photograph.

Limbs that are stretched towards you are tricky to draw because you do not see their actual length. To duplicate these foreshortened appendages, rely heavily on what your eye tells you and use a straight edge to compare length and angles with other parts of the body.

When the animal is too far away to see individual hairs, short scribbled contour lines work well to suggest the coat. Pay attention to hair direction.

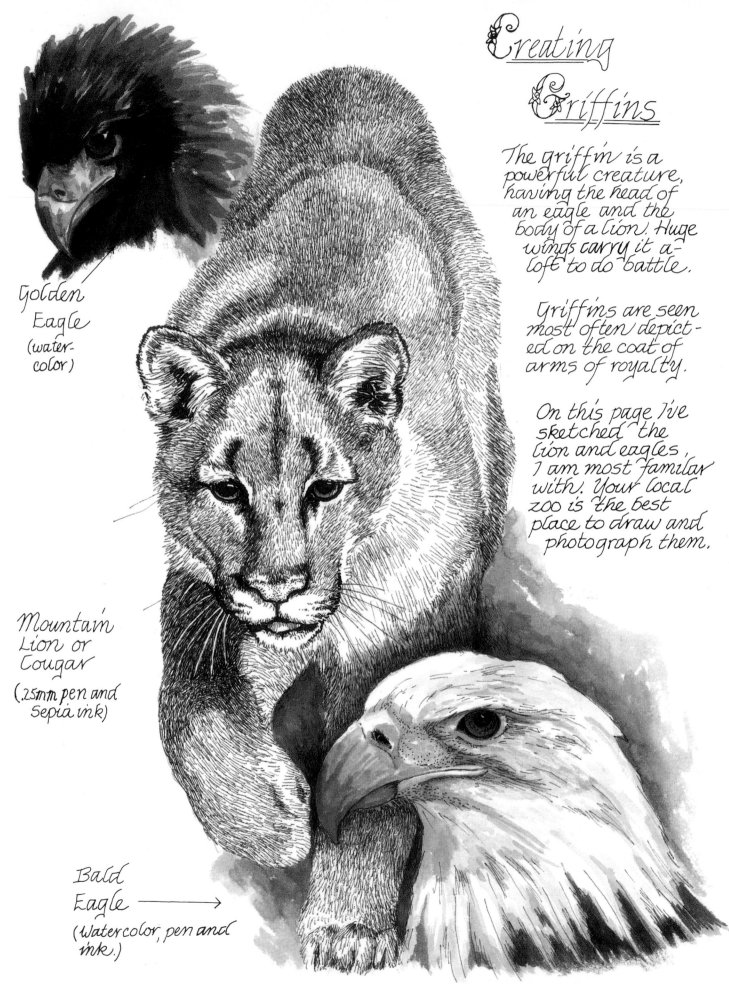

Creating Griffins

The griffin is a powerful creature, having the head of an eagle and the body of a lion. Huge wings carry it aloft to do battle.

Griffins are seen most often depicted on the coat of arms of royalty.

On this page I've sketched the lion and eagles, I am most familiar with. Your local zoo is the best place to draw and photograph them.

Golden Eagle (watercolor)

Mountain Lion or Cougar (.25mm pen and Sepia ink)

Bald Eagle ⟶ (Watercolor, pen and ink.)

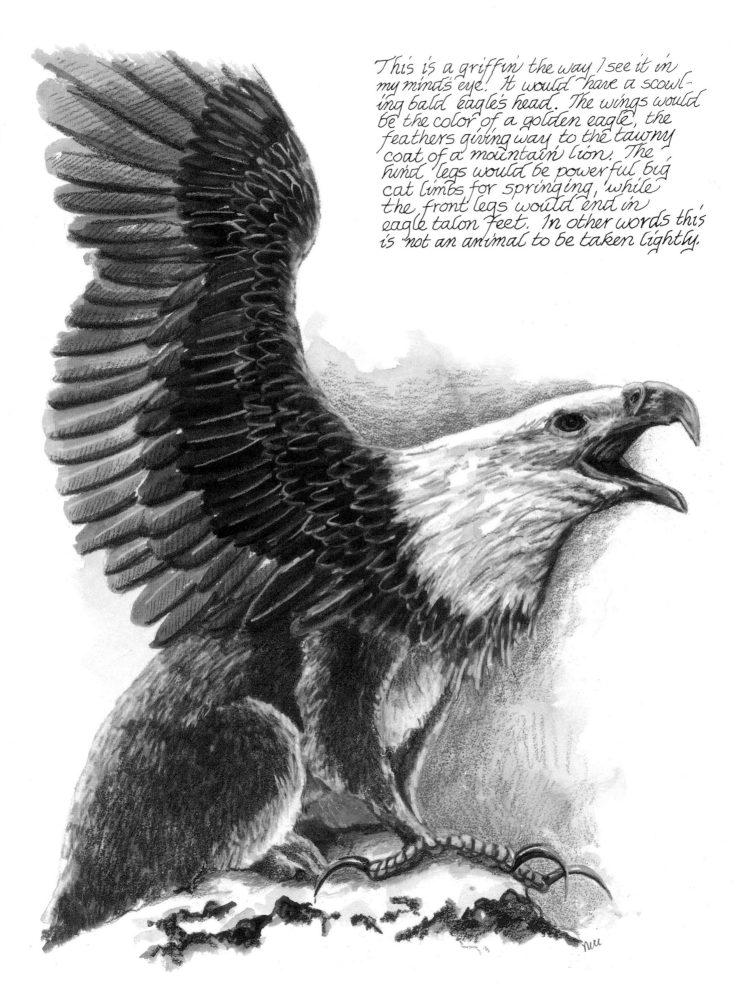

This is a griffin the way I see it in my mind's eye. It would have a scowling bald eagle's head. The wings would be the color of a golden eagle, the feathers giving way to the tawny coat of a mountain lion. The hind legs would be powerful big cat limbs for springing, while the front legs would end in eagle talon feet. In other words this is not an animal to be taken lightly.

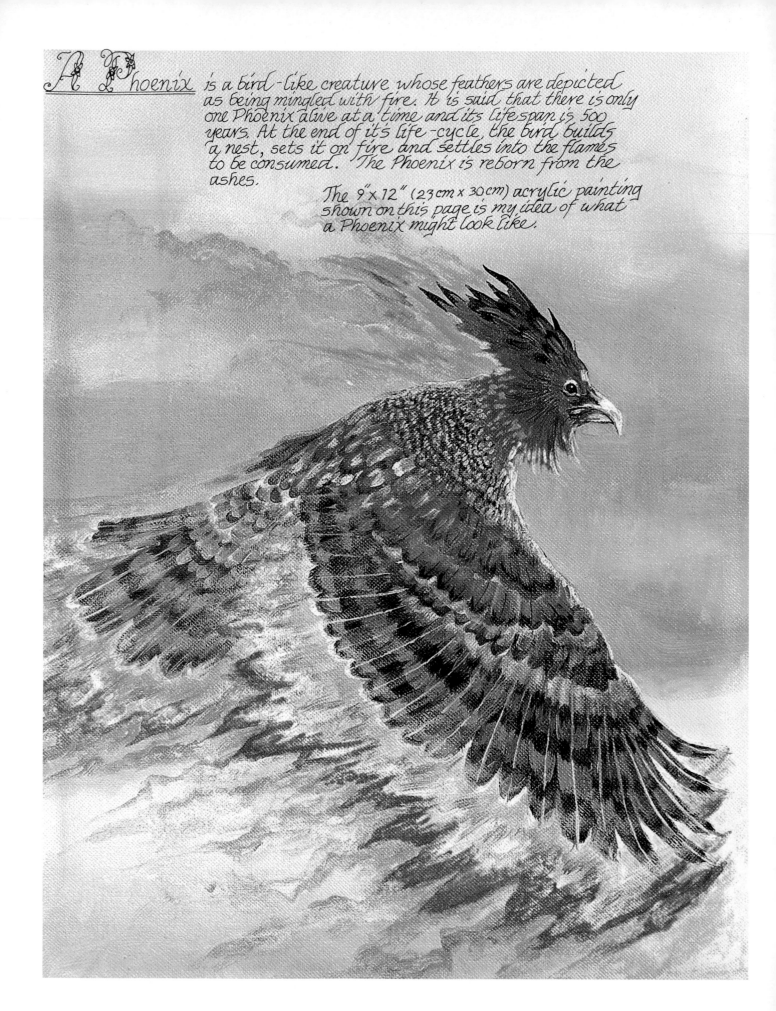

A Phoenix is a bird-like creature whose feathers are depicted as being mingled with fire. It is said that there is only one Phoenix alive at a time and its life span is 500 years. At the end of its life-cycle, the bird builds a nest, sets it on fire and settles into the flames to be consumed. The Phoenix is reborn from the ashes.

The 9" x 12" (23cm x 30cm) acrylic painting shown on this page is my idea of what a Phoenix might look like.

Hummingbird Creatures

These combination animals are a product of my imagination. How did I think them up? As I write this chapter, it has turned to spring. Not only are the daffodils blooming in the flowerbeds, but the busy little hummingbirds are feeding at my window feeders. Down at the pond the frogs are singing loud enough for me to hear in my studio. Inside, my foundling kitten, Catzilla, is actively playing hunting games at my feet. These familiar things were my inspiration. Work with creatures you know best before attempting to depict the more exotic animals.

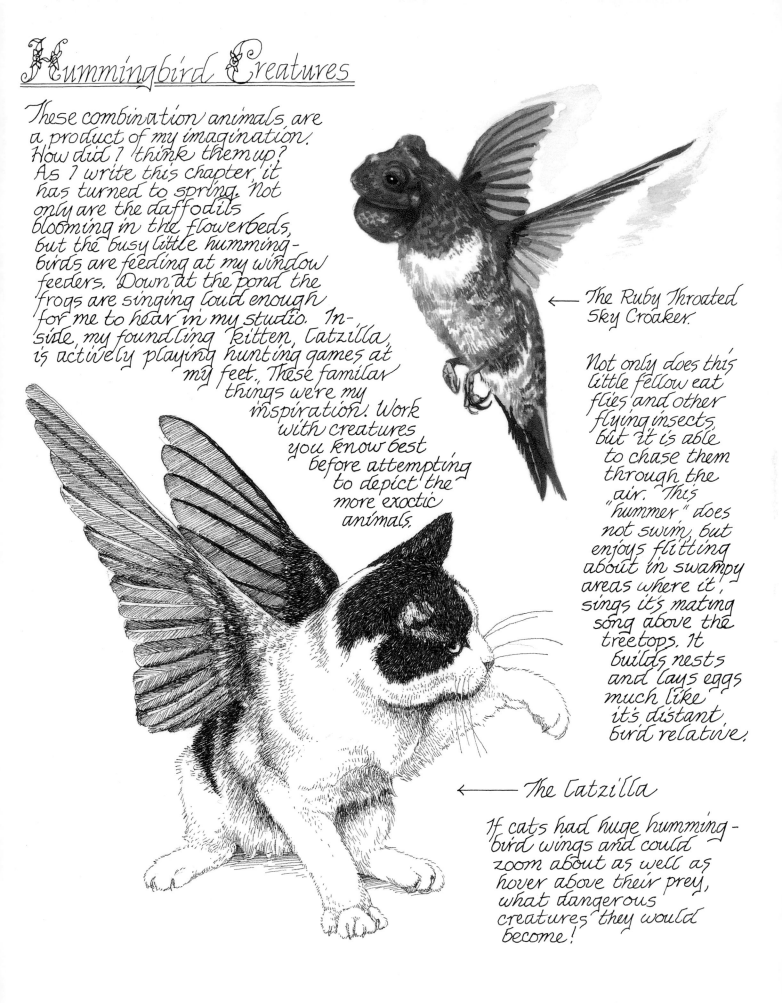

← The Ruby Throated Sky Croaker.

Not only does this little fellow eat flies and other flying insects, but it is able to chase them through the air. This "hummer" does not swim, but enjoys flitting about in swampy areas where it sings it's mating song above the treetops. It builds nests and lays eggs much like it's distant bird relative.

← The Catzilla

If cats had huge hummingbird wings and could zoom about as well as hover above their prey, what dangerous creatures they would become!

Fish

Before taking the plunge to create mermaids and other fantasy creatures of the deep, I'd advise getting your feet wet by first sketching a fish or two. Here are the basics.

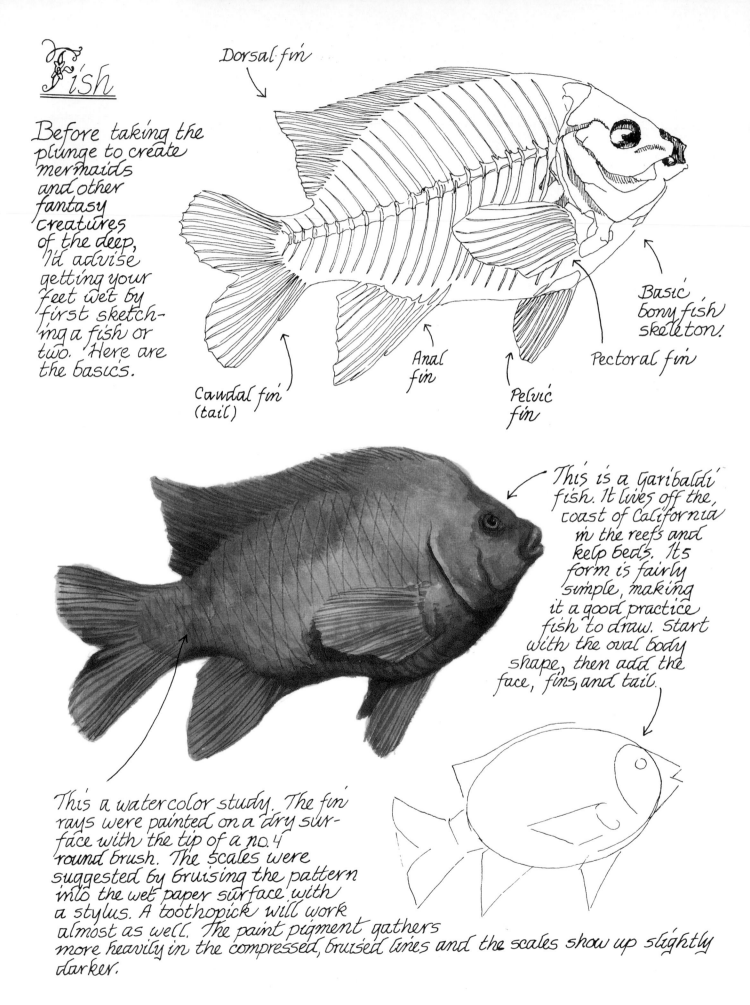

Dorsal fin

Basic bony fish skeleton.

Pectoral fin

Caudal fin (tail)

Anal fin

Pelvic fin

This is a Garibaldi fish. It lives off the coast of California in the reefs and kelp beds. Its form is fairly simple, making it a good practice fish to draw. Start with the oval body shape, then add the face, fins, and tail.

This a watercolor study. The fin rays were painted on a dry surface with the tip of a no. 4 round brush. The scales were suggested by bruising the pattern into the wet paper surface with a stylus. A toothpick will work almost as well. The paint pigment gathers more heavily in the compressed, bruised lines and the scales show up slightly darker.

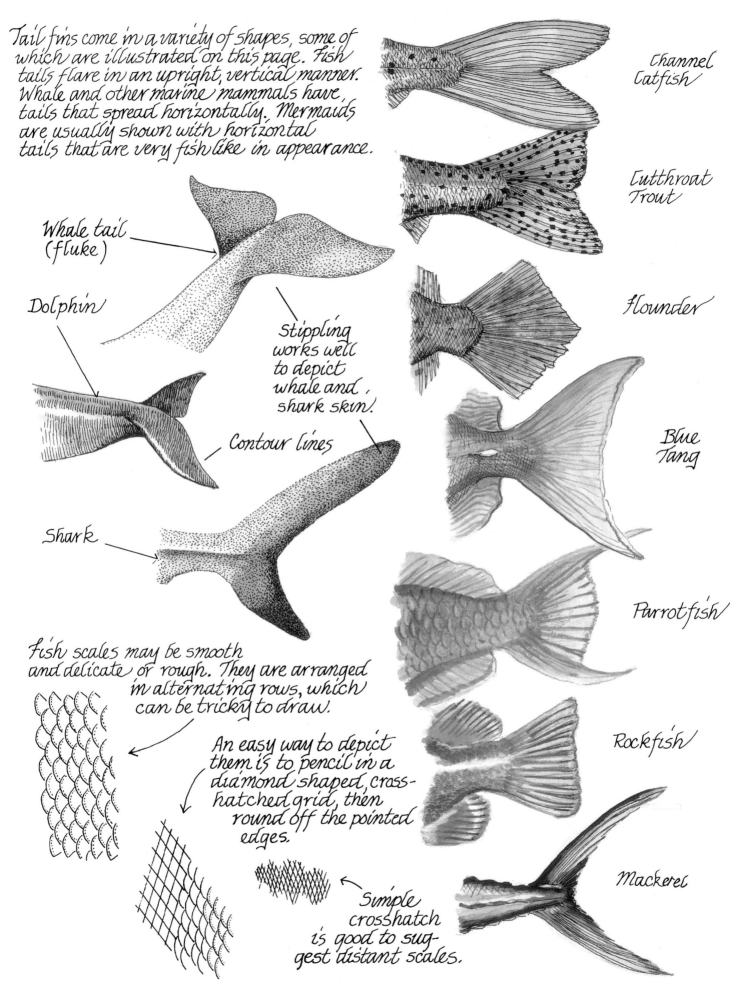

Tail fins come in a variety of shapes, some of which are illustrated on this page. Fish tails flare in an upright, vertical manner. Whale and other marine mammals have tails that spread horizontally. Mermaids are usually shown with horizontal tails that are very fish-like in appearance.

Channel Catfish

Cutthroat Trout

Whale tail (fluke)

Dolphin

Stippling works well to depict whale and shark skin.

Flounder

Contour lines

Blue Tang

Shark

Parrotfish

Fish scales may be smooth and delicate or rough. They are arranged in alternating rows, which can be tricky to draw.

Rockfish

An easy way to depict them is to pencil in a diamond shaped, cross-hatched grid, then round off the pointed edges.

Mackerel

Simple crosshatch is good to suggest distant scales.

Mythical Mixed Creatures 97

Mermaids and Mermen

Mer-people are legendary creatures of the sea, having the tail of a fish or ocean mammal and the body of a human from the waist up.

.25 mm pen nib.

facial expression is a key element in the portrayal of a living subject. This merman shows intense curiosity as he watches an airplane fly by. →

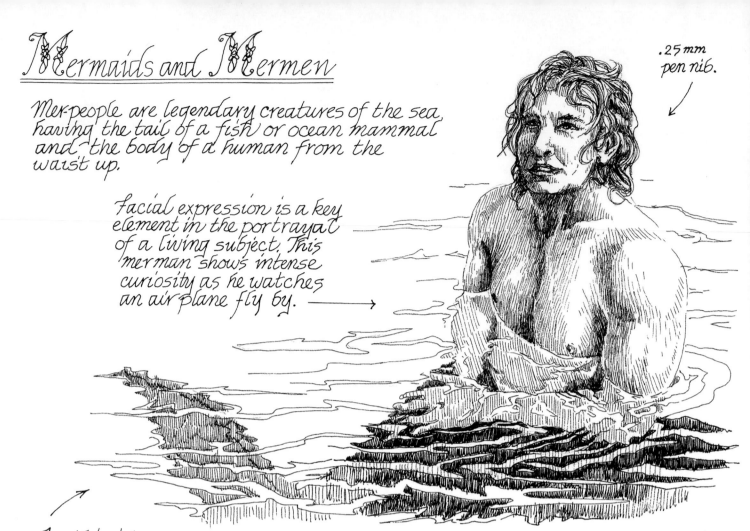

In this ink drawing the merman rests partially submerged against a rock outcropping. Note that the underwater portions of his body are indistinct, distorted, and interrupted by rippling water lines.

I imagine that exploring sunken shipwrecks and finding the hidden treasures they hold would be a favorite pastime for the mer-people. The merman to the left searches for a special necklace for a favorite mermaid.

This mini painting is done in watercolor with touches of pen and ink work. The texture on the tail was brushed in while the paint was still wet.

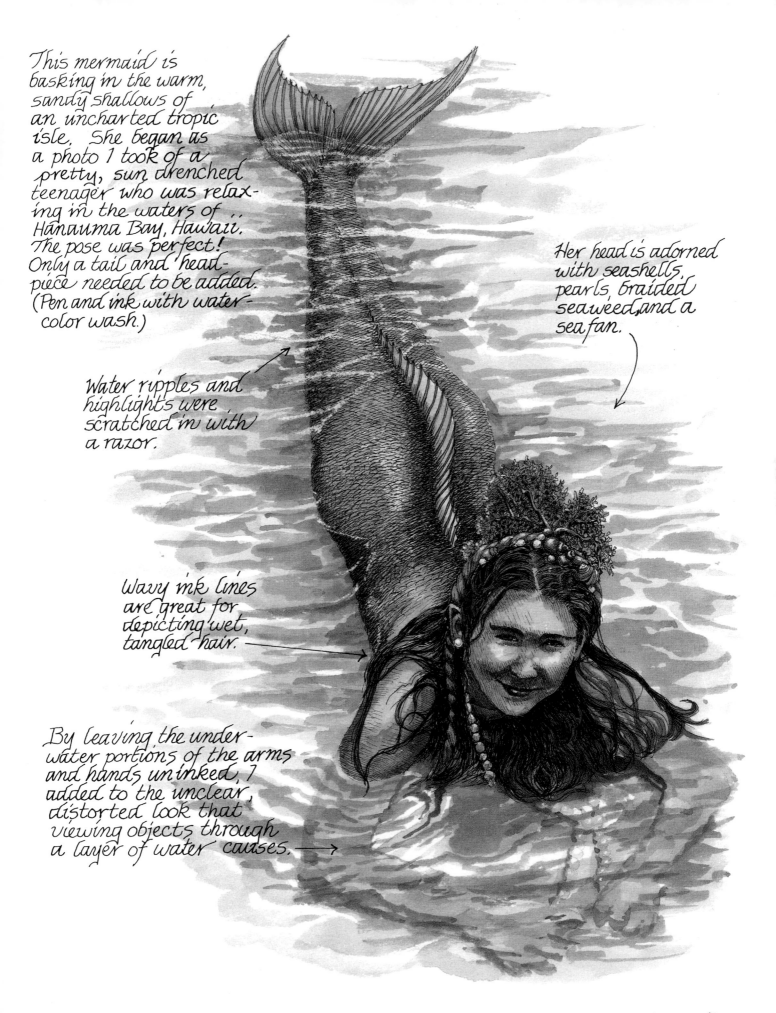

This mermaid is basking in the warm, sandy shallows of an uncharted tropic isle. She began as a photo I took of a pretty, sun drenched teenager who was relaxing in the waters of Hanauma Bay, Hawaii. The pose was perfect! Only a tail and head-piece needed to be added. (Pen and ink with water-color wash.)

Water ripples and highlights were scratched in with a razor.

Her head is adorned with seashells, pearls, braided seaweed, and a sea fan.

Wavy ink lines are great for depicting wet, tangled hair.

By leaving the under-water portions of the arms and hands uninked, I added to the unclear, distorted look that viewing objects through a layer of water causes.

There is a legend that beneath the tail of a mermaid is hidden a set of human legs and feet. Should she wish to shed her tail and become a land creature, she may. However the tail and the ability to live in the sea would be lost forever.

The mermaid in the painting on the opposite page, "Contemplation," 8"x10" (20cm x 25cm), is reflecting what life as a human might be like. The painting is pen, ink, and watercolor. The ink was applied using nib sizes .18mm through .50mm. Stroking the pen work only in the foreground where I wished to emphasize the texture or add definition, added a special dimensional quality to the painting. When the ink is applied first and then tinted with washes of color, as was done in the mermaid painting, it tends to take on an illustrative look that resembles the old tinted post cards. It's a fun, fantasy technique.

Green sea turtle

plate-like scales

The bead-like scales of the mermaids' tail were patterned after a sea turtle. Here is how I did it, step by step.

① Pencil in the scale shapes and apply Winsor & Newton Art Masking Fluid to the spaces between the scales, using an old, soaped, round detail brush or the The Incredible Nib tool. Let it dry.

② Paint in the scale sections using washes of Phthalocyanine Blue and Green, and mixtures of the two. Add tiny amounts of red-orange to tone down the hue or create shadow tones. Add Payne's Gray for deep shadows. Let dry.

③ If scale color dries too pale, glaze on another coat. Let dry.

Daub off the masking fluid using a rubber cement removal block or masking tape wrapped around your finger, sticky side out.

④ Paint the area between the scales with a light wash of Yellow Ochre.

Let dry.

⑤ Darken each scale with a glaze of the original color applied to the bottom and right hand edge. (The area opposite the light source.) Let dry.

⑥ Add a Yellow Ochre plus violet shadow beneath each scale.

Scratch a highlight into the top, left-hand portion of each scale using a razor blade.

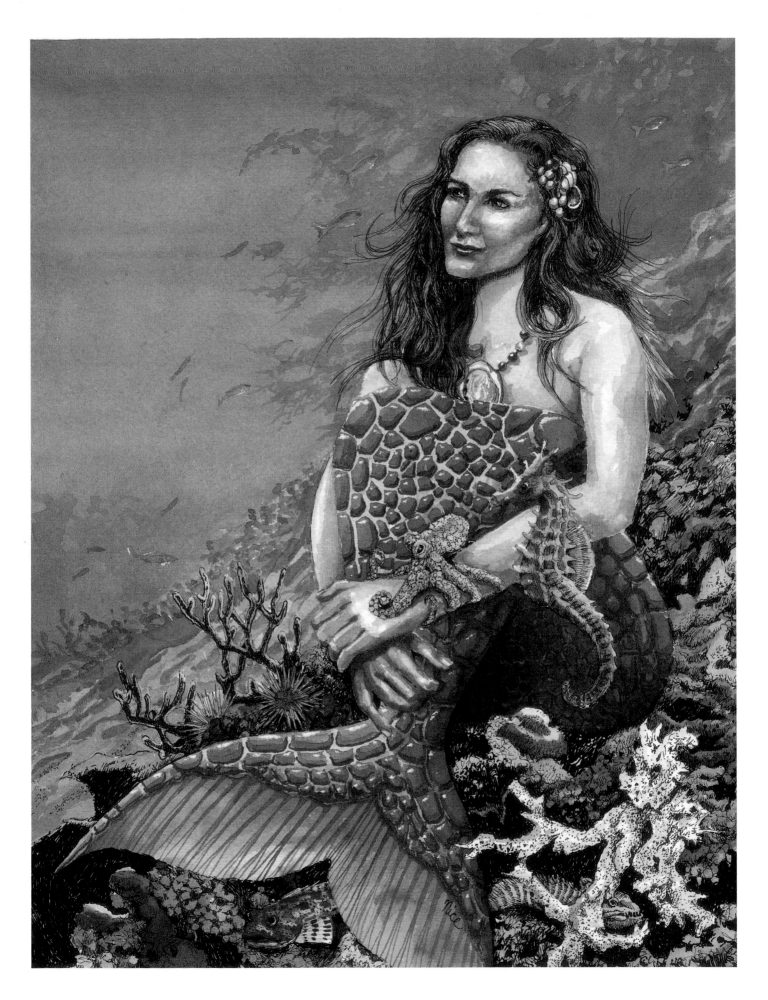

Goats, Fauns and Satyrs

Fauns and satyrs are creatures of the forest, having the upper torso of a man and the ears, horns, and legs of a goat. Satyrs are the wilder of the two. According to mythology it was the riotous, lascivious satyrs that served Bacchus his wine. Both of the man-goat creatures are fond of music and are said to be the masters of the Pan pipe, a musical instrument made of reeds or hollow tubes.

Pan pipe →

In order to draw a faun or satyr, it is advisable for you to become familiar with the basic shape of a goat by drawing a few. The legs are especially important.

Front legs and hoofs.

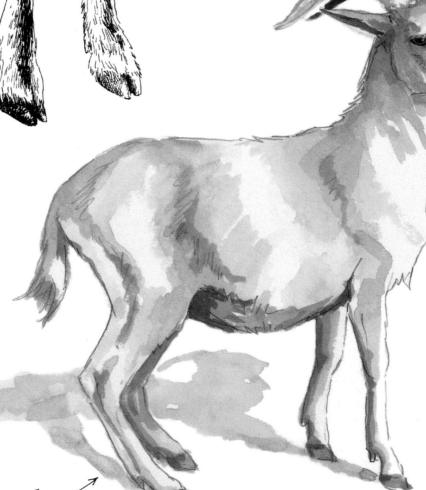

Hind leg and cloven hoof.

Don't forget the beard.

This goat sketch was done in pencil and watercolor wash.

This pen, ink, and watercolor wash drawing illustrates a satyr playing his pan pipe. Scribbled ink lines worked well to texture the thick forest undergrowth and the satyr's hairy arms and chest.

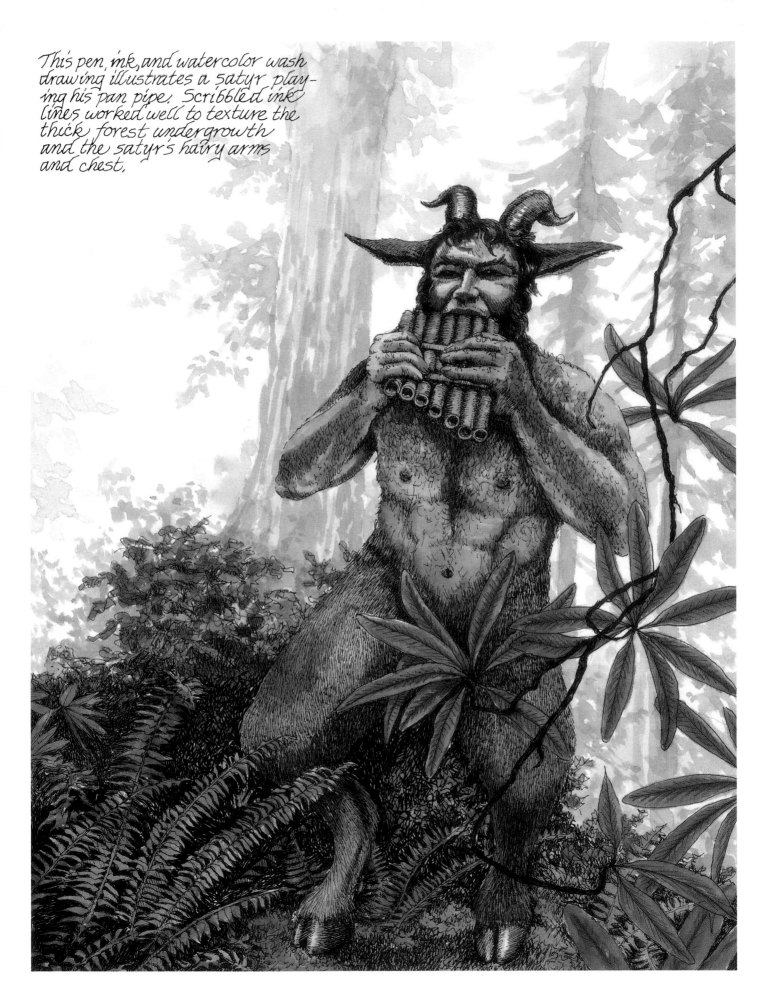

Just for Fun

I've created these non-mythical, mixed creatures from my own imagination. I took my sketchbook and camera to the Portland, Oregon zoo and let the inspiration flow over me.

On location pencil study of a crocodile.

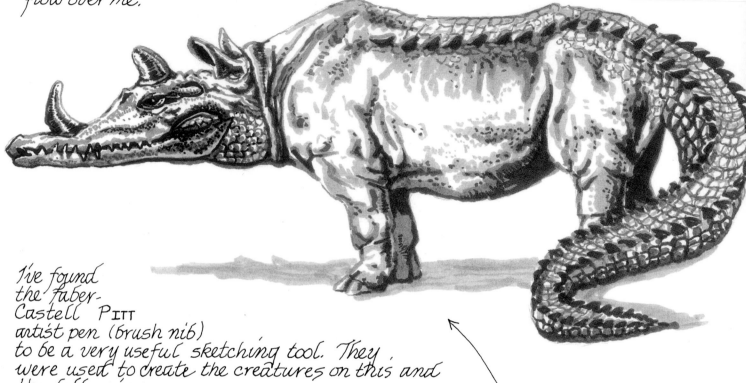

I've found the Faber-Castell PITT artist pen (brush nib) to be a very useful sketching tool. They were used to create the creatures on this and the following page.

The Croc'onoceros

This scary creature is at home in the water or on land. He is a bad tempered croc that can gallop after his prey and knock them down with a swipe of his rhino horns. Thank goodness he is just a fantasy!

Picture of a rhinoceros taken at the zoo. It made a good reference photo. What animal would you combine with it?

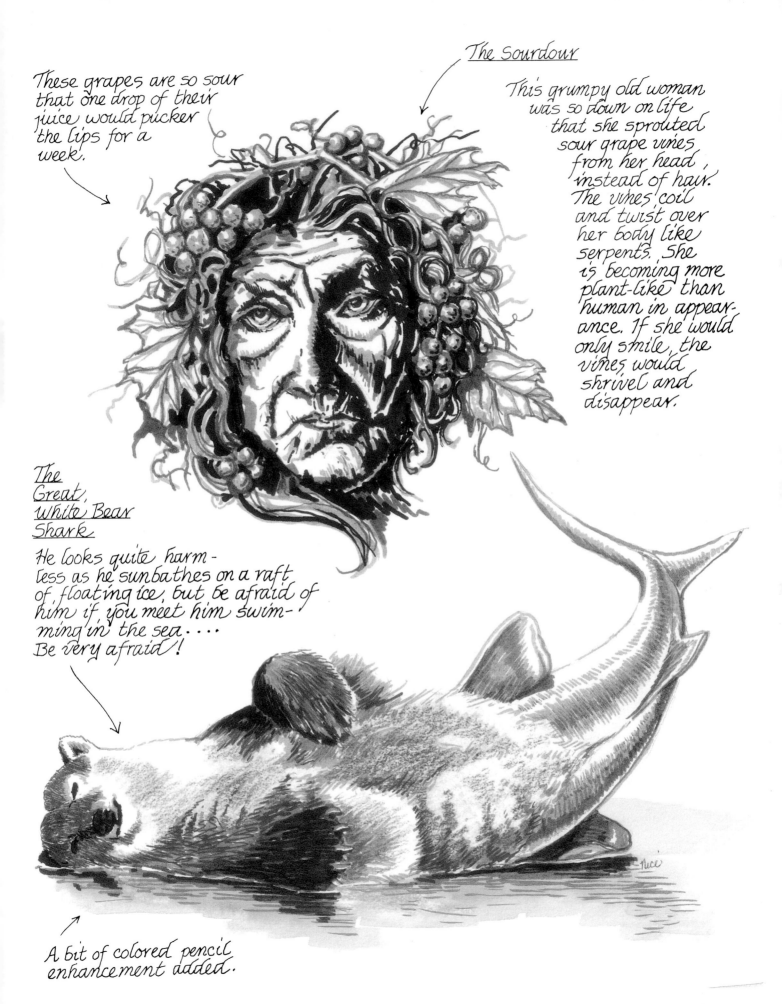

These grapes are so sour that one drop of their juice would pucker the lips for a week.

<u>The Sourdour</u>

This grumpy old woman was so down on life that she sprouted sour grape vines from her head, instead of hair. The vines coil and twist over her body like serpents. She is becoming more plant-like than human in appearance. If she would only smile, the vines would shrivel and disappear.

<u>The Great, White Bear Shark</u>

He looks quite harmless as he sunbathes on a raft of floating ice, but be afraid of him if you meet him swimming in the sea.... Be very afraid!

A bit of colored pencil enhancement added.

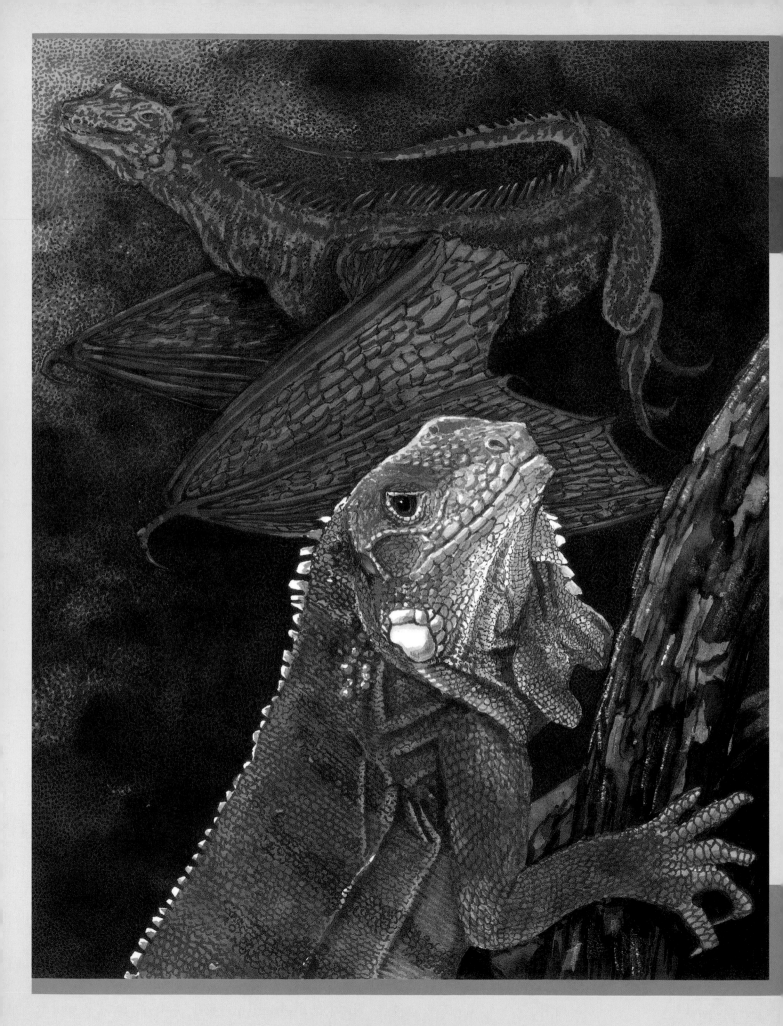

CHAPTER 5
Dragons & Sea Monsters

There has always existed opposition in all things, sadness to oppose happiness, weakness to oppose strength and of course evil to oppose good. In the dark ages, the greatest evil that anyone could come up with was black magic. There was also a great fear of fire, which could destroy crops and homes, and great carnivorous beasts capable of overpowering a strong, well armed man. Wrap all of these threats into one entity and give it the power of flight and you have a dragon. Tales of these magnificent beasts have long stirred the heart of storytellers, making heroes of knights and frightening small children into good behavior. Along the same train of thought, if you send a dragon out to sea, trade its wings for fins and add the salty yarn of a sailor, you have a sea monster. Descriptions of both beasts are so varied and vague that they make wonderful fodder for the artist's imagination. I enjoyed photographing and sketching various reptiles, then adding features from other creatures to morph them into mean and mighty dragons and sneaky sea serpents.

I call the painting on the opposite page "When Iguanas Dream." It was painted using a combination of pen, ink, and watercolor. The background is watercolor with an overlay of Pitt brush tip pen stippling. As you can see, iguanas make wonderful dragon models. Feel free to use the lizard photos in this chapter as references. Now let your imaginary monsters out of their lairs and have fun sketching.

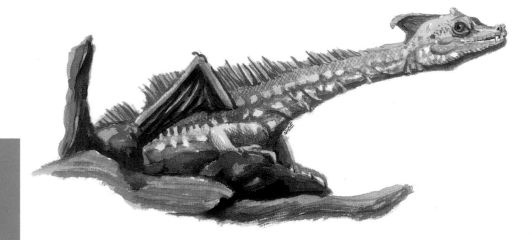

When Iguanas Dream
Pen, Ink, and Watercolor
8" × 10" (20cm × 25cm)

Reptile Scales

Large lizards make excellent dragon models. Study the arrangement and shape of the scales on the lizards in the photographs. There are three types of scales ----

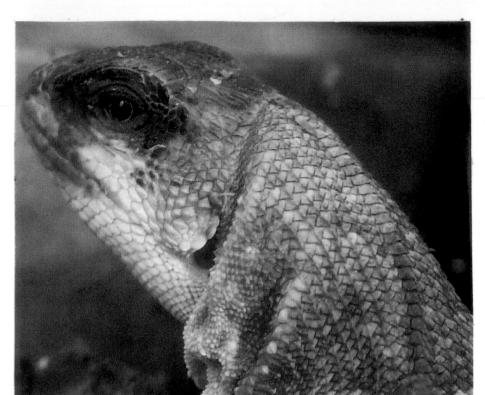

 Smooth

 Keeled

 Granular ('bead-like')

The scales of **the** lizard painted in watercolor below were first sketched lightly in pencil. While areas were still moist from preliminary washes, a stylus was used to "bruise" in the outline of the scales.

A Pitt brush pen was used to enhance the keeled scales.

Simple brush strokes can suggest scales.

Half moon strokes over dry wash.

No. 4 round brush.

Brush tip dabs over a dry wash.

I photographed the iguana on this page in a pet store. I did a detailed pen and ink drawing of his scaly head using a .25 mm Rapidograph pen.

Stippling, scribble strokes, parallel lines and contour lines were used to shade and add texture to the drawing.

If the face were lengthened and the spikes enlarged, this iguana would look very dragon-like.

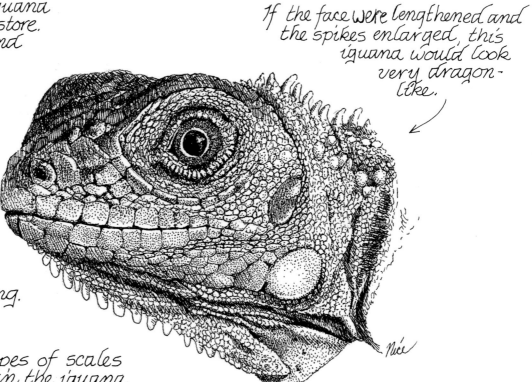

All three types of scales can be seen in the iguana photo.

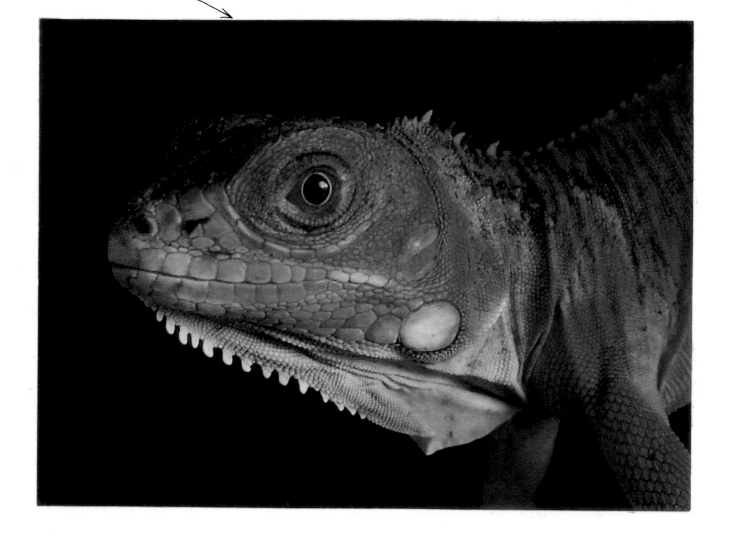

Reptilian Features

This rotating chameleon eye might be used to create a dragon that can see in all directions.

Rapidograph .25 mm. pen.

This is the eye of a Blue tongued skink. It was painted using watercolor washes. It would be just right for a fire-breathing dragon.

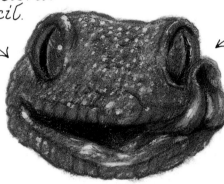

Colored pencil.

This Gecko face is a bit **too cute** to be used for an adult dragon, but could be transformed into a hatchling.

Here is the eye of an asp viper. Very dragonish!

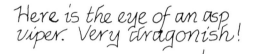

Pitt brush tip ink pens were used.

A no. 2 pencil sketch of a crocodile eye.

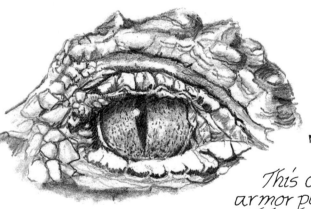

This croc's armor plating would look good on a dragon.

I'm not sure if there are any venomous dragons, but **if you** should dream one up, here is a pencil drawn viper fang to work from.

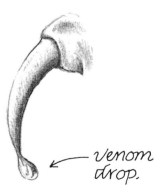

venom drop.

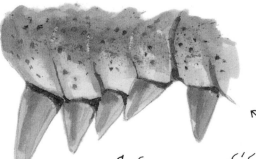

A few crocodile teeth would give any dragon a wicked smile!

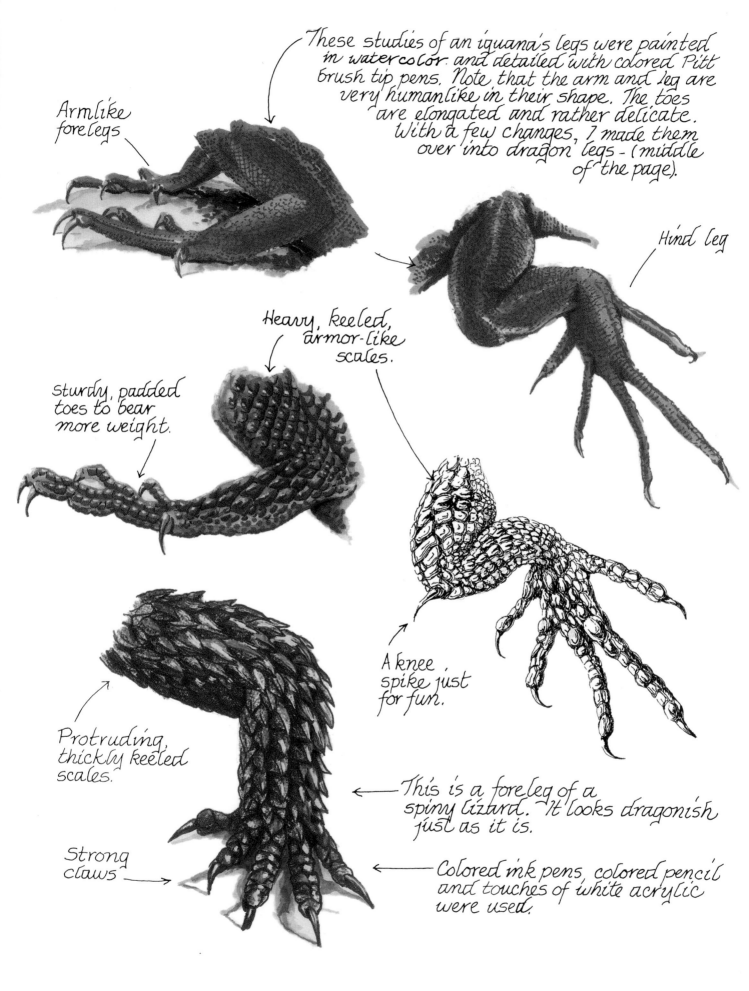

These studies of an iguana's legs were painted in watercolor and detailed with colored Pitt brush tip pens. Note that the arm and leg are very humanlike in their shape. The toes are elongated and rather delicate. With a few changes, I made them over into dragon legs - (middle of the page).

Armlike forelegs

Hind leg

Heavy, keeled, armor-like scales.

Sturdy, padded toes to bear more weight.

A knee spike just for fun.

Protruding, thickly keeled scales.

This is a foreleg of a spiny lizard. It looks dragonish just as it is.

Strong claws

Colored ink pens, colored pencil and touches of white acrylic were used.

Featherless Wings

I imagine that dragon wings must look a lot like those of the prehistoric Pteranodon, big, fleshy and featherless. Since there are not many Pteranodons around to use as models, I've turned to a smaller example of featherless wings --- the bat.

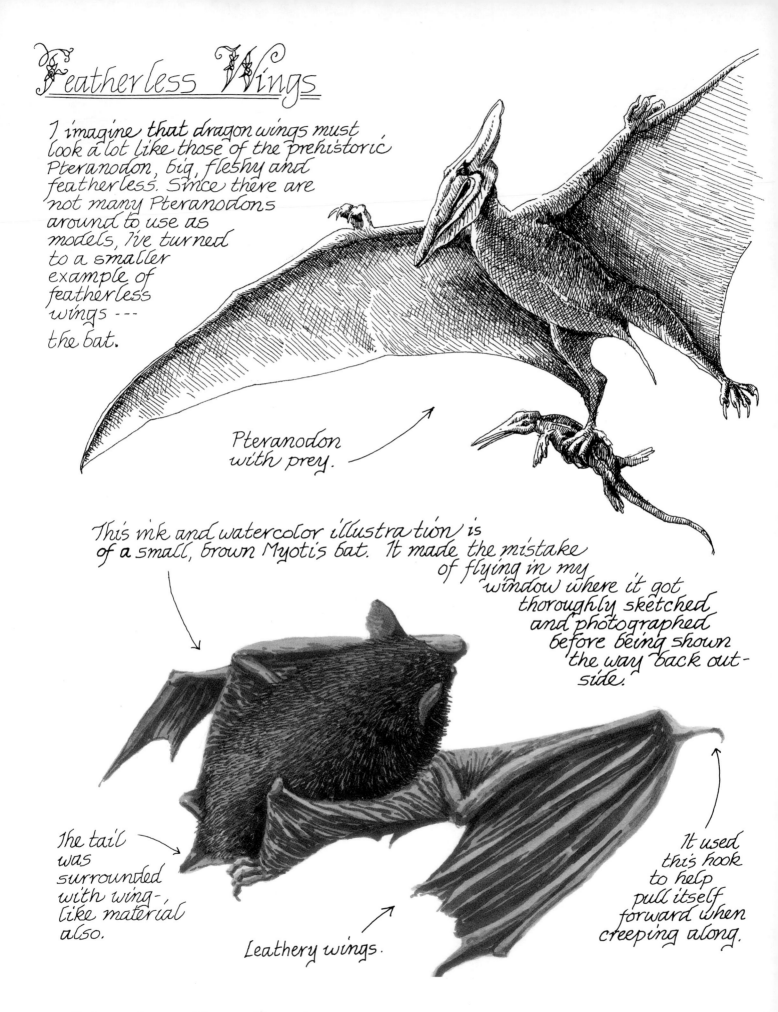

Pteranodon with prey.

This ink and watercolor illustration is of a small, brown Myotis bat. It made the mistake of flying in my window where it got thoroughly sketched and photographed before being shown the way back outside.

The tail was surrounded with wing-like material also.

Leathery wings.

It used this hook to help pull itself forward when creeping along.

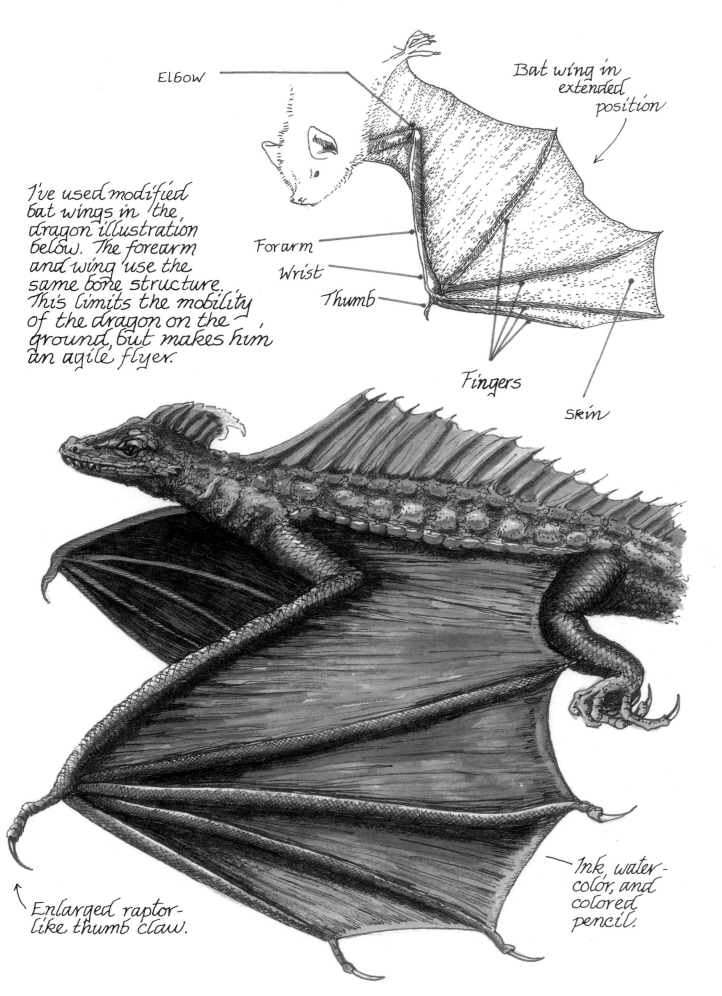

Elbow

Bat wing in extended position

I've used modified bat wings in the dragon illustration below. The forearm and wing use the same bone structure. This limits the mobility of the dragon on the ground, but makes him an agile flyer.

Forearm

Wrist

Thumb

Fingers

Skin

Enlarged raptor-like thumb claw.

Ink, water-color, and colored pencil.

From Iguana to Dragon

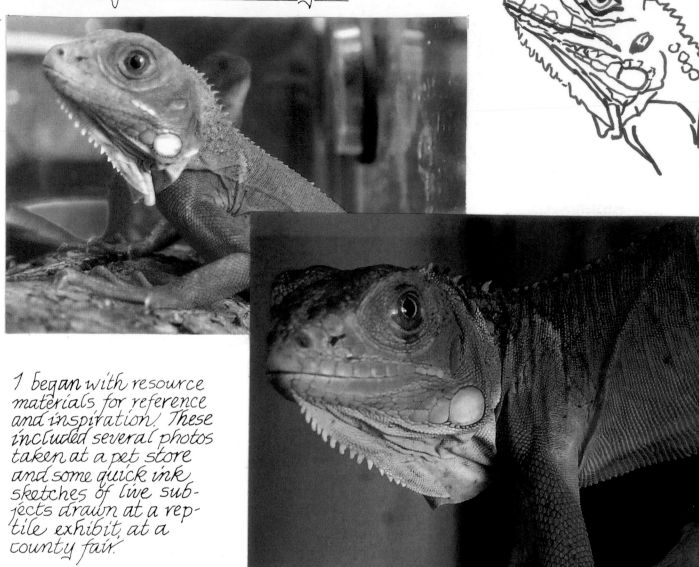

I began with resource materials for reference and inspiration. These included several photos taken at a pet store and some quick ink sketches of live subjects drawn at a reptile exhibit at a county fair.

With practice, shape, texture and even a bit of personality can be captured with a few scribbly pen strokes. I try to carry both a camera and a small 5" x 7" (13 cm x 18 cm) sketch book when going out.

This Iguana took under five minutes to sketch!

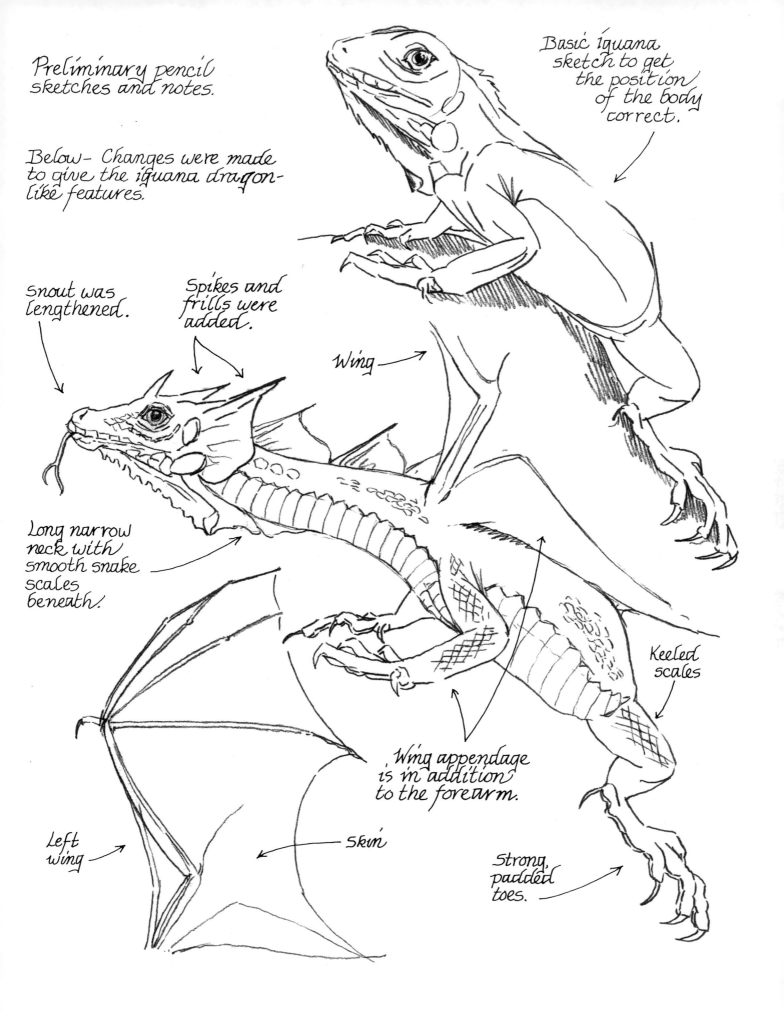

Preliminary pencil sketches and notes.

Below- Changes were made to give the iguana dragon-like features.

Basic iguana sketch to get the position of the body correct.

snout was lengthened.

Spikes and frills were added.

Wing

Long narrow neck with smooth snake scales beneath.

Keeled scales

Wing appendage is in addition to the forearm.

Left wing

Skin

Strong, padded toes.

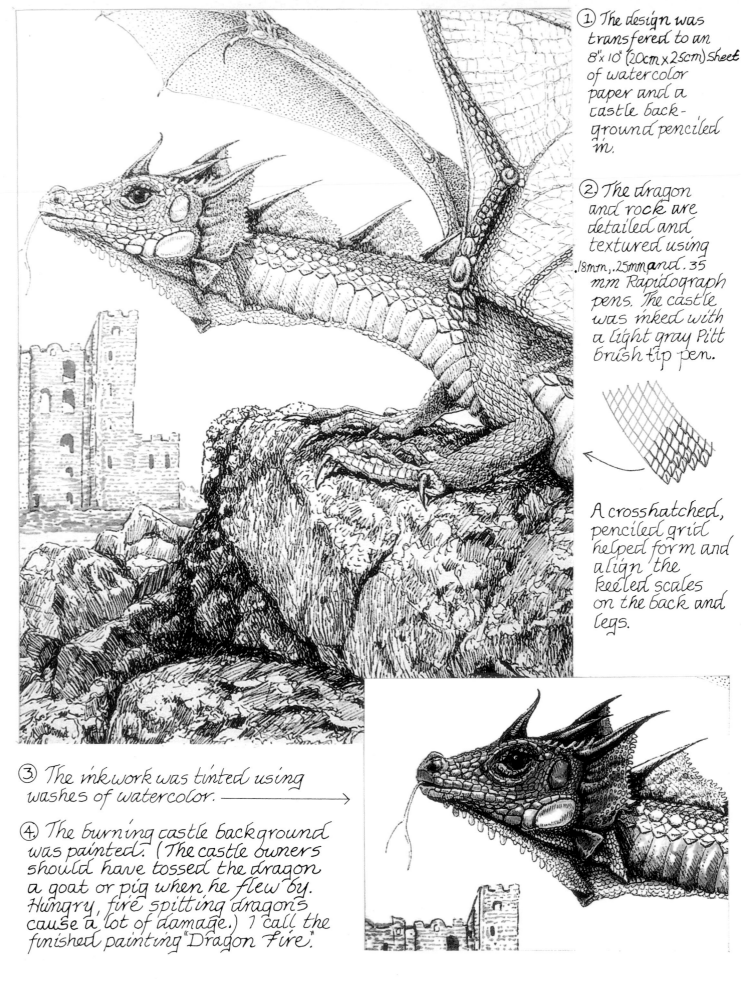

① The design was transferred to an 8"x 10" (20cm x 25cm) sheet of watercolor paper and a castle background penciled in.

② The dragon and rock are detailed and textured using .18mm, .25mm and .35 mm Rapidograph pens. The castle was inked with a light gray Pitt brush tip pen.

A crosshatched, penciled grid helped form and align the keeled scales on the back and legs.

③ The ink work was tinted using washes of watercolor. ⟶

④ The burning castle background was painted. (The castle owners should have tossed the dragon a goat or pig when he flew by. Hungry, fire spitting dragons cause a lot of damage.) I call the finished painting "Dragon Fire".

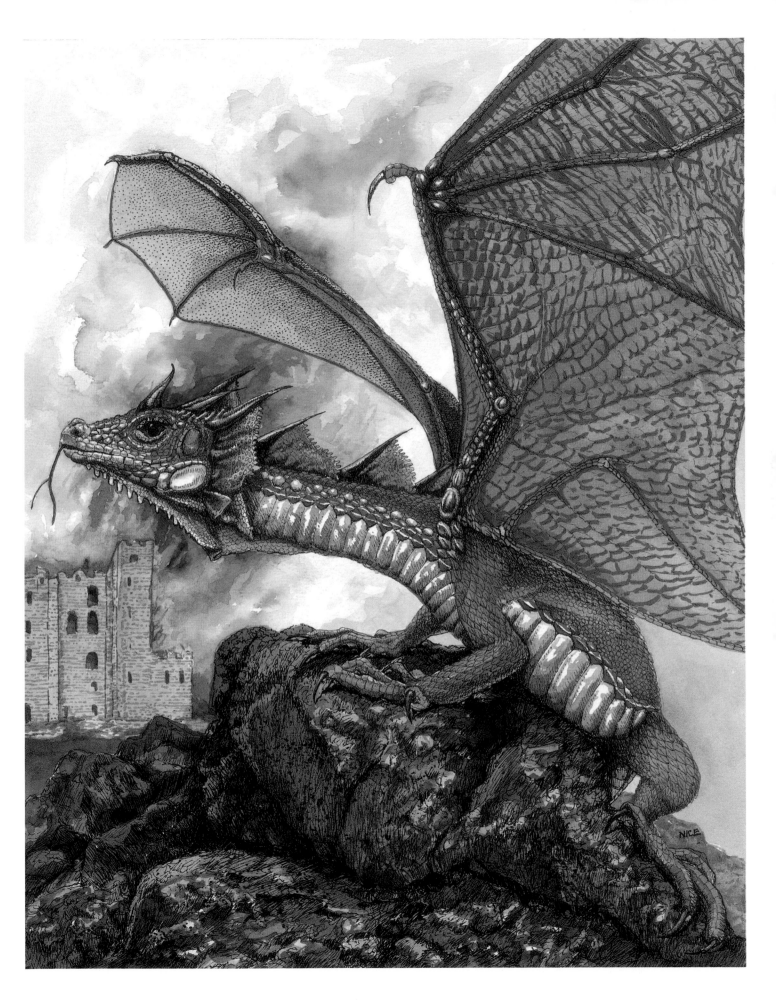

Alligator Dragon

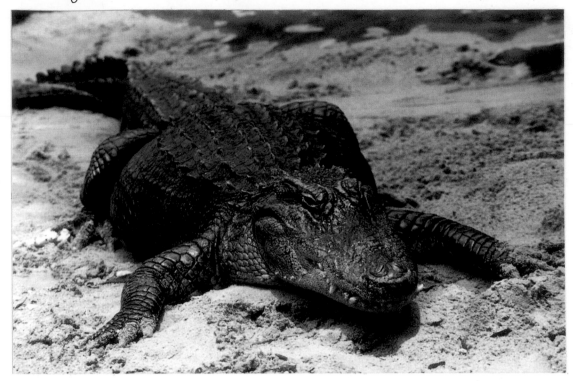

I photographed this alligator in Florida at a reptile reserve. He looks pretty wicked just the way he is.

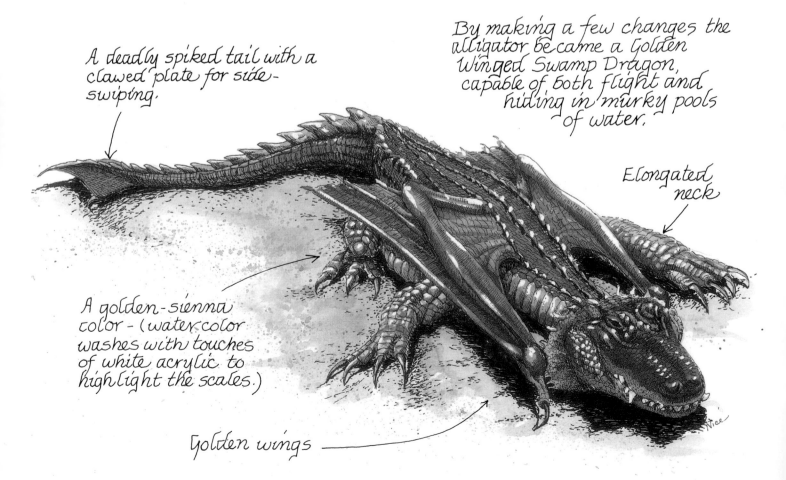

By making a few changes the alligator became a Golden Winged Swamp Dragon, capable of both flight and hiding in murky pools of water.

A deadly spiked tail with a clawed plate for side-swiping.

Elongated neck

A golden-sienna color - (water color washes with touches of white acrylic to highlight the scales.)

Golden wings

Horses as Models

Horse heads make elegant dragon por- traits.

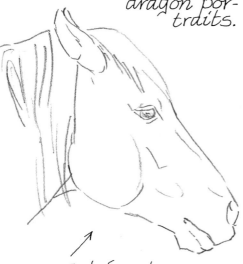

Mustang photo taken at the Kentucky Horse Park.

↑
Sketch out the basic horse head in pencil.

A long neck will add grace to the dragon.

Enlarge the nostrils and add scales and horns.

This is a Blue Northern Dragon. It lives in a huge ice cave and is active even in the winter. Several polar bears share its cave and they curl up together for warmth.

More Dragons

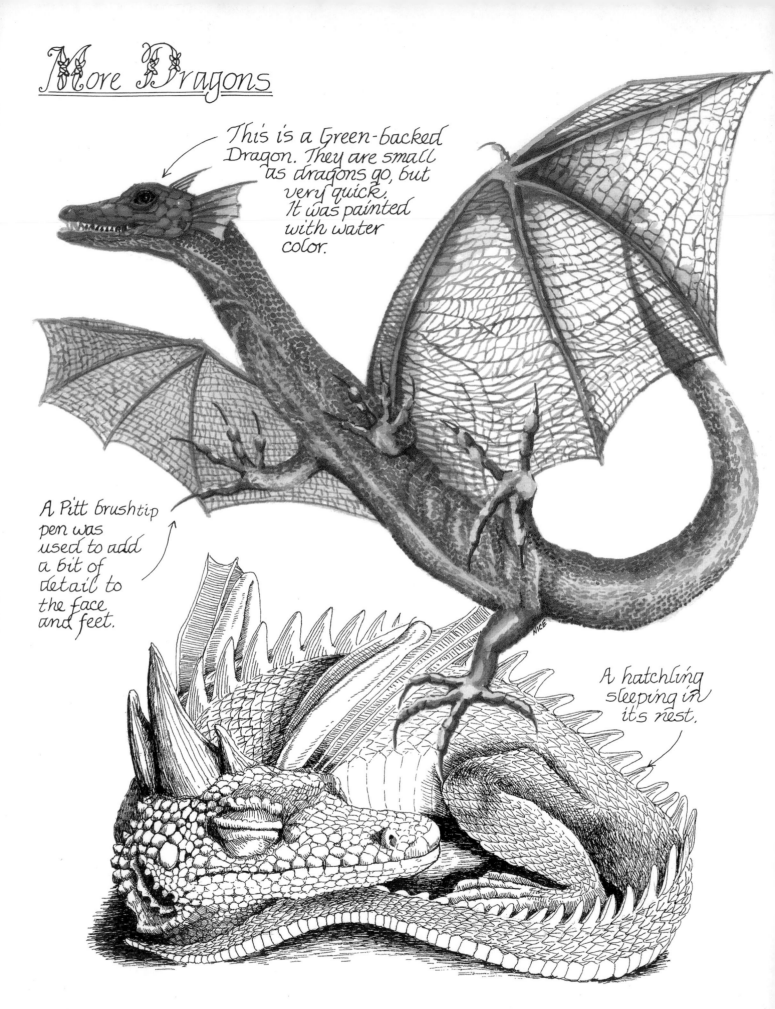

This is a Green-backed Dragon. They are small as dragons go, but very quick. It was painted with water color.

A Pitt brush tip pen was used to add a bit of detail to the face and feet.

A hatchling sleeping in its nest.

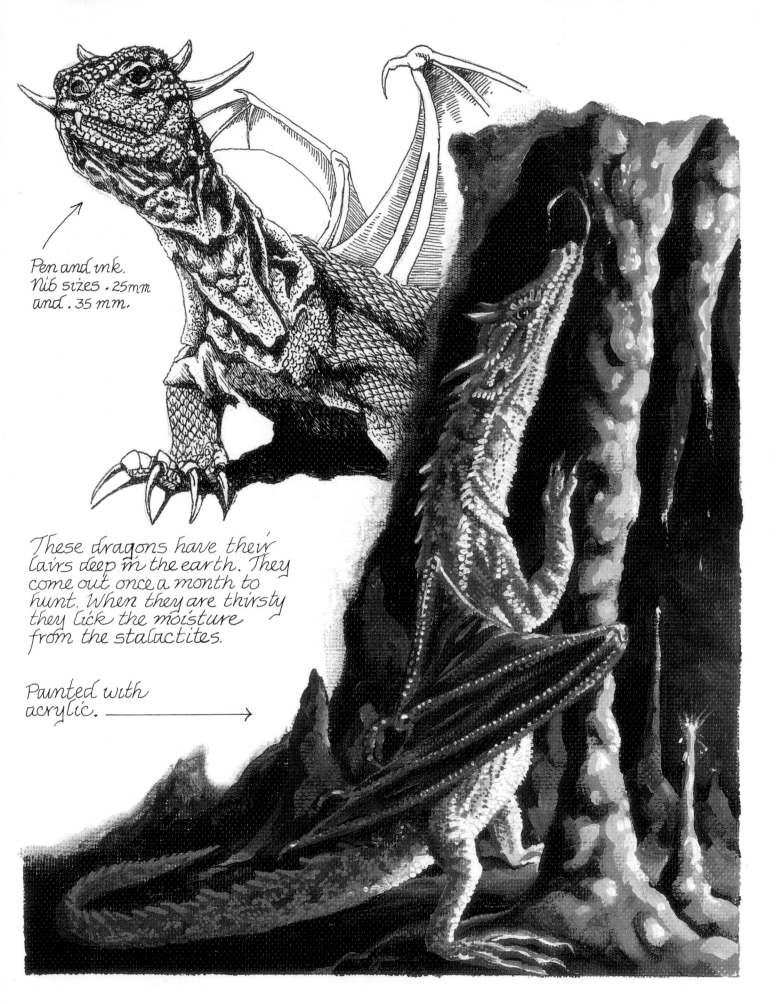

Pen and ink.
Nib sizes .25mm
and .35 mm.

These dragons have their
lairs deep in the earth. They
come out once a month to
hunt. When they are thirsty
they lick the moisture
from the stalactites.

Painted with
acrylic. ⟶

Sea Monsters

The main difference between dragons and sea monsters is that the latter is adapted to life in the water. Instead of wings, fire and claws, think fins, paddle-like legs, and long sharp teeth.

Most of the sea and deep lake monsters I've seen illustrated have been patterned after the plesiosaurs of the Jurassic period. In fact if there still are sea monsters some believe that they may be plesiosaurs. The deep water dinosaurs sketched on this page are from my imagination, although I did base them on photos I saw of fossil skeletons.

Pliosaurus (Plesiosaur) had a large head and a short neck.

Vicious teeth

Cryptocleidus (plesiosaur) had a long neck which could whip quickly about to capture its prey.

I imagined this one to have shark-like skin, but scales would have looked good also.

Consider the plesiosaurs but don't close off your imagination to other possibilities. Who knows what lurks in the deep watery realms. Whatever you dream up may prove to be reality!

Paddle like legs.

Nice

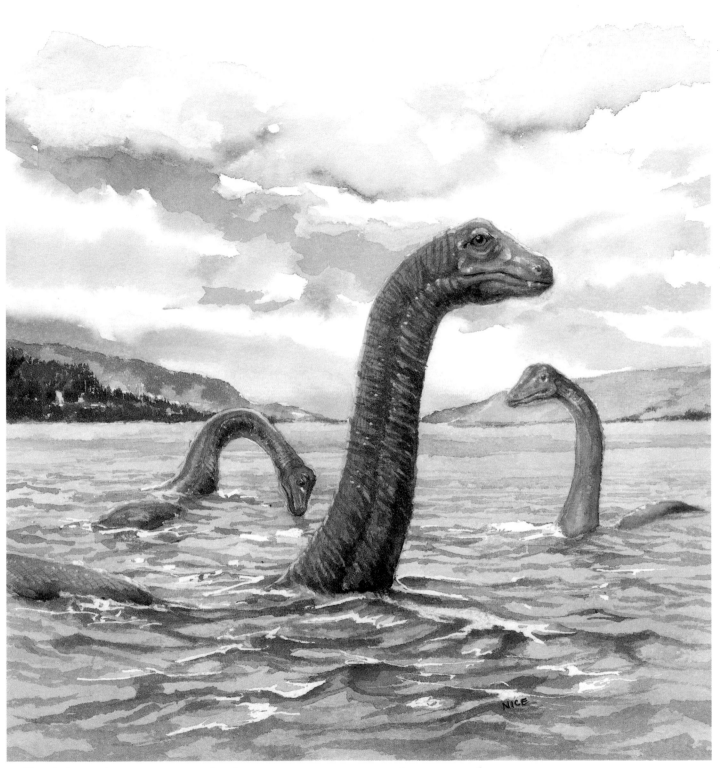

The Monsters of Loch Ness (above), was painted using washes of water-color in a glazing technique. It illustrates "Nessie" and her family basking in the sun.

Sea Serpents

These huge, lengthy creatures resemble legless dragons with snakelike bodies. Sea serpents prowl the depths of the ocean realms and play amidst storm tossed seas. According to legend, they can coil about a great sailing ship and drag it down to a watery grave.

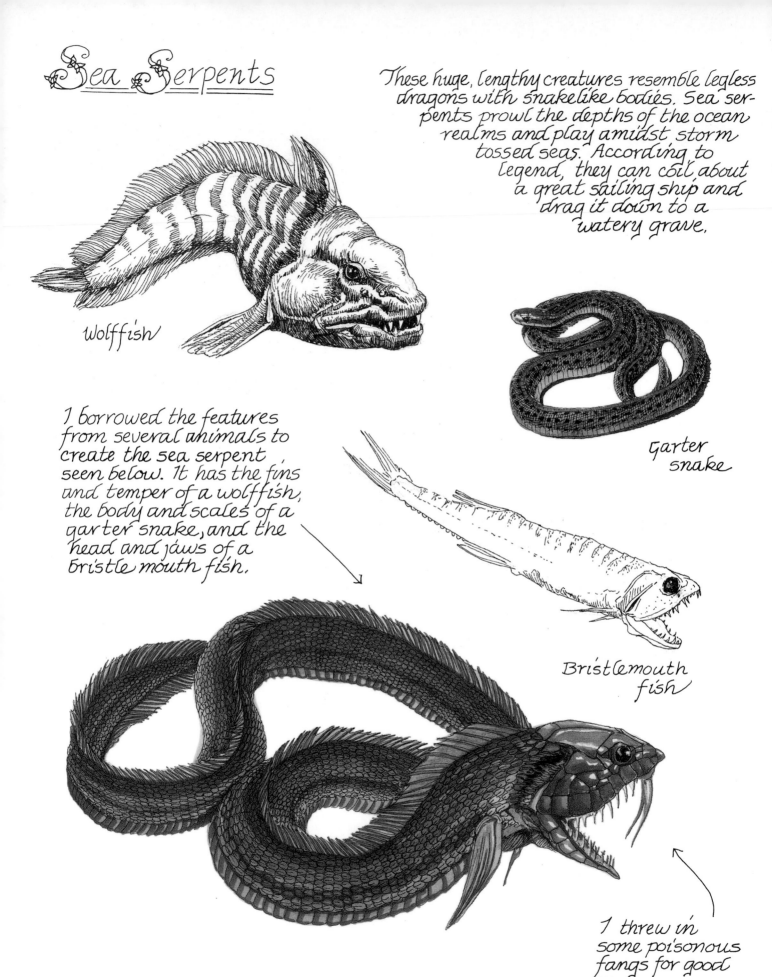

Wolffish

I borrowed the features from several animals to create the sea serpent seen below. It has the fins and temper of a wolffish, the body and scales of a garter snake, and the head and jaws of a bristle mouth fish.

Garter snake

Bristlemouth fish

I threw in some poisonous fangs for good measure.

By combining the color and poison spines of the thornyhead fish with the head and scales of a crocodile, I've created the nasty sea serpent seen in the lower half of this page.

I call this denizen of the deep — Rusty Snap Jaws. He is particularly fond of tourists who lean over the railings of cruise ships.

The illustration is mixed media.

Blue green waters of the tropical Pacific.

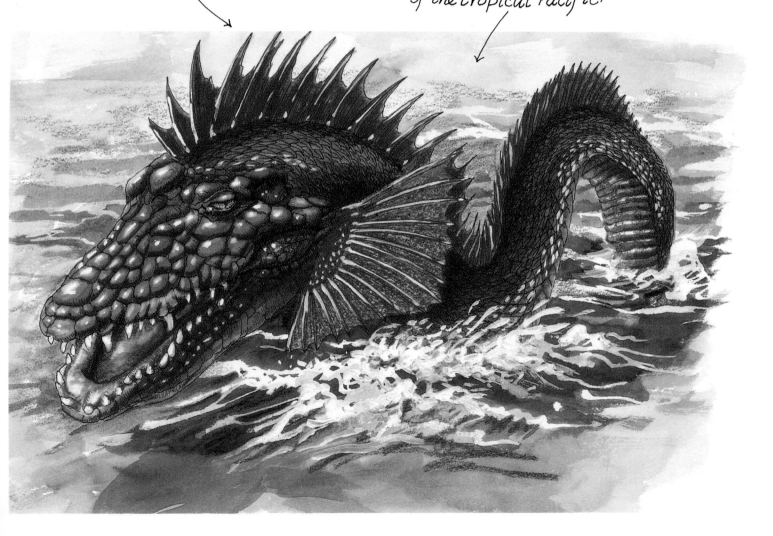

Index

The Watercolor Bible

The answers to most every common, real-life situation the watercolorist will encounter can be found in this easy-to-use ultimate guide that is organized topically, is compact and has an enclosed spiral binding. This complete and definitive book on watercolor techniques and principles is for both beginner and advanced artists Explore essential watercolor techniques and practice over 20 easy-to-follow step-by-step demonstrations on a variety of popular subjects.

ISBN 1-58180-648-5, HARDCOVER W/CONCEALED WIRE-O, 304 PAGES, #33237

DragonArt: How to Draw Fantastic Dragons and Fantasy Creatures

Fantasy fans of all ages learn dragon and fantasy creature drawing basics through more than 30 progressive step-by-step demonstrations and awe-inspiring finished art. No other book features fantasy-style dragons and beasts in a simple step-by-step format. This book gives simple and complete drawing instruction with the added bonus of spectacular finished pieces on one of the hottest trends in drawing for people of all ages.

ISBN 1-58180-657-4, PAPERBACK, 128 PAGES, #33252

The Drawing Bible

The answers to most every common, real-life situation the artist who chooses to draw will encounter can be found in this easy-to-use ultimate guide that is organized topically, is compact and has an enclosed spiral binding. This is the only book on drawing you'll ever need—it covers all standard drawing materials (black & white and color). Provides the tools for personal expression such as mixing media and exploring a variety of surfaces and styles. Follow many step-by-step demos provide plenty of clear visual instruction.

1-58180-620-5, HARDCOVER W/CONCEALED WIRE-O, 304 PAGES, #33191

The Ultimate Guide to Painting from Photographs

This book is ideal for those painters who aspire to achieve beautiful pictures without learning painting theory. By focusing on the basic nuts and bolts needed to create a successful composition—a reference photo, a list of materials and simple step-by-step instruction—this book provides the reader with an immediate path to painting better pictures. Forty detailed step-by-step demonstrations help the reader develop confidence in his or her ability to create paintings using their own reference materials. This book provides the reader with an opportunity to experiment with many different styles and mediums (watercolor, oil, acrylic, colored pencil, pastel and mixed media), guaranteeing something for every artist.

ISBN 1-58180-717-1, PAPERBACK, 208 PAGES, #33389

How to Keep a Sketchbook Journal

More than a diary of written words, a sketchbook journal allows you to indulge your imagination and exercise your artistic creativity. It is a personal, private place where you have unlimited freedom to express yourself, experiment, discover, dream and document your world. The possibilities are endless. In *How to Keep a Sketchbook Journal*, Claudia Nice shows you samples from her own journals and provides you with advice and encouragement for keeping your own. She reviews types of journals, from theme and garden journals to travel journals and fantasy sketchbooks, as well as the basic techniques for using pencils, pens, brushes, inks and watercolors to capture your thoughts and impressions.

ISBN 1-58180-044-4, HARDCOVER, 128 PAGES, #31912